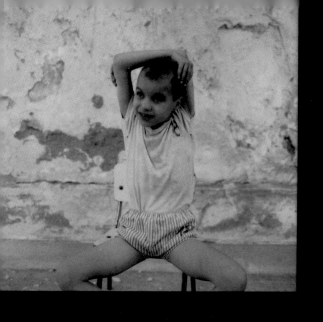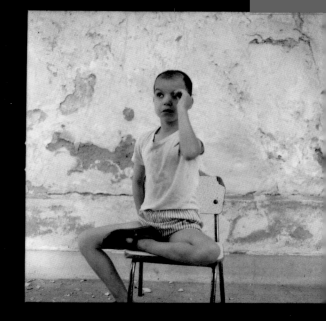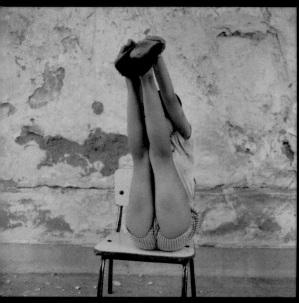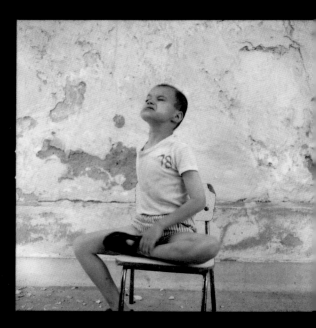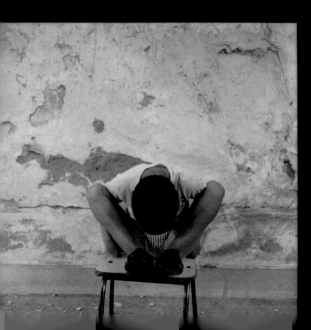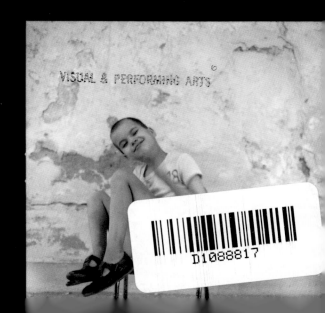

VISUAL & PERFORMING ARTS

*This book is dedicated
to every HIV-positive child in Romania,
their parents, and to all the
dedicated staff at the children's homes,
hospitals, and NGOs who continue to fight
for the right of these children
to have a decent life.*

ica

Children of Ceausescu

Photographs by Kent Klich | Essay by Herta Müller

VISUAL & PERFORMING ARTS

Umbrage | journal

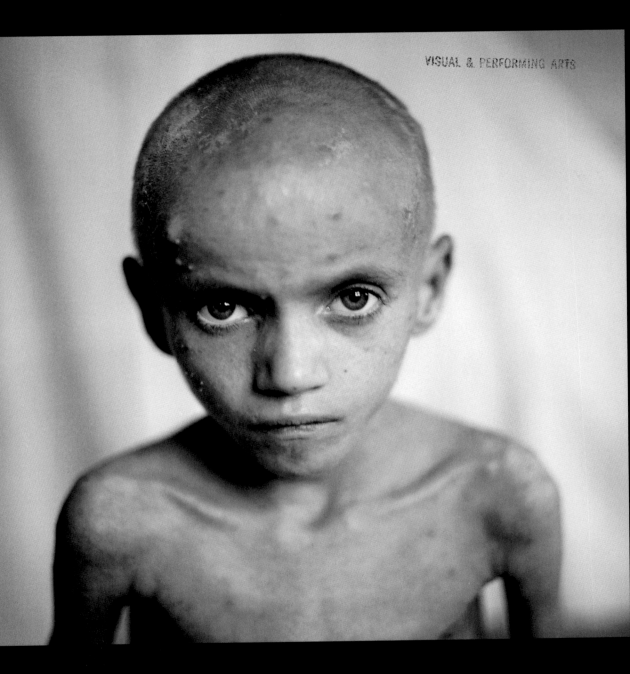

VISUAL & PERFORMING ARTS

A good person is worth as much as a piece of bread

by Herta Müller

I LIVED IN ROMANIA UNTIL 1987, three years before the dictator Ceausescu's fall from power. I was only 34 when I left the country, but my nerves were so shattered from the constant political harassment that I felt like an old woman. Worn down by the secret police and ignored by the indifferent party rank and file, in the end I was a burden to myself, an "enemy of the state" to the government, and a highly suspect figure to my fellow citizens. I often thought about the mentality which I encountered all around me. It was a mixture of ignorance and brutishness.

I WAS A TEACHER, and I saw how this same mentality was taught to the children. In the staff room, no one spoke to me. They looked straight through me as if I were made of glass. It was too risky for them to have any contact with me. Every day, I steeled myself to face the world. I refused to follow the curriculum, argued in meetings, and stood my ground. But within myself, I felt quite different. I would go to the washrooms and flush the toilet a few times so that no one would hear me crying. Then I would reapply my mascara at the mirror and face my colleagues as if nothing had happened. The school was on the edge of town, and the children were from poor families. The pall of their families' poverty hung all around them: hands full of warts and rough as turkey-necks, cold sores round their mouths, gaps in their teeth, lice in their hair, fleas in their clothes, holes in their shoes, filthy books and paper. But the lessons were one cynical lie about socialist progress and the people's happiness. Shunned by the other teachers, I felt most comfortable with the children in my class – even though they didn't understand that I risked not only my career but my life if I refused to indoctrinate them. Of course, they noticed that I skipped over the many eulogies to the party when we worked through our textbooks in class. But

they didn't realise that I was trying to protect them from this brainwashing. Lying was a normal part of school – they could not imagine what it was like to speak the truth out loud. We eyed each other: I saw their poverty, which I could do nothing to change, and they sensed my isolation and felt a quiet liking for me, even though they never asked themselves why I was different from the other teachers. Of course I wished they could understand the risks I was taking. But although this hurt me too, I realised that they were already compromised, deadened by privation and accustomed to obeying. They had no other choice.

FIVE CHILDREN PER FAMILY, the law said. There was no contraception and abortion was a crime. As a result, there were the orphanages, which made tragic headlines around the world after the dictator's fall from power. They were for the children with no parents, whose mothers were in prison after an illegal abortion or dead at the hands of some back-street abortionist. Guilt-ridden, their fathers slid into alcoholism. Then the state would put the two or three surviving children into an orphanage. The healthy ones were groomed for the secret police's special units; the sick and disabled wasted away in their own filth – the flotsam of an uncaring, insane society.

The school books said that children were "the light of the country," that Ceausescu was "the father of all children," his wife "the mother of all children." In a tragic sense, this was true. So many children just stopped coming to school one day because they died. They died from tonsilitis, appendicitis, pneumonia, or even an infected tooth. And that was that: the child's name was removed from the register, and no more was said. There was no point in moaning about it, for that would have meant talking about the reasons why it was happening. And it was

happening because of the state the country was in. At most people said: "That's life." Or more callously: "Anyone born is old enough to die." If someone fell ill and called an emergency doctor, the first thing the hospital asked was: "How old is the patient?" If they were over 60, they wouldn't send an ambulance. The state made no secret of the individual's zero value. It was the law of natural selection. Your lifespan depended solely on your physical stamina; if you were blessed with a strong constitution, you lived longer. If you were more delicate, that was your hard luck. No one complained. They expected to die from a minor ailment. It was just one of those things; there was no bread, no electricity, no heating, no milk, soap or toothpaste, no toilet paper or underwear, and there were no aspirins, bandages, or throat drops either.

I was always dismissed from the schools. But because I had no job and was a "parasitic element," I had to report to the secret police. They threatened me with prison, and told me many times that a "road accident" could happen. Unemployed, I wandered around aimlessly, avoiding the streets where there were schools – for whenever I heard children playing in the school yard, I started to cry.

But then I found a job in a kindergarten. I thought to myself, a kindergarten can't possibly be as bad as a school; there must be room for a little bit of childhood somewhere in this country. Surely the little ones are spared the routine destructiveness of ideology. They'll have building blocks, dolls, and dancing. How cruelly deluded I was.

On my first day, the director of the kindergarten took me to my group. As we entered the classroom, she said somewhat cryptically, "The anthem, children!" Automatically, the children sprang to attention and formed a semi-circle, hands pressed to their sides, heads back, eyes turned upwards. Little children had jumped up from their tables, but little soldiers stood

the semi-circle and sang. There was more screaming and bellowing than singing. It seemed to be the volume and standing to attention that counted. The anthem was very long, and a great many verses had been added in recent years. I think it had reached about seven verses by then. Having been unemployed for so long, I was completely out of touch and didn't know the words to the new verses. After the last verse, the semi-circle broke open and the children started rampaging around again. The stiff little soldiers were boisterous little children once more. The director took a cane from the shelf. "You'll need this," she said. Then she whispered in my ear and called four of the children over to her. Take a good look at them, she said, and sent the four back to their places. Then she told me that their parents or grandparents held senior functions in the party. The one little boy is the party secretary's son, she said, so you have to be particularly careful. He can't stand being contradicted, and you have to protect him from the others, no matter what he gets up to. Then she left me alone with the group. There were about ten canes lying on the shelf, pencil-thick switches as long as rulers. Three of them were broken into pieces.

It was snowing outside — the first big fluffy flakes to lie that year. "Let's sing a song about winter, shall we?" I said, "Who knows a winter song?" A winter song? They didn't know any. So I asked them for a song about summer instead. They shook their heads. Well then, how about an autumn or a spring song? At last, a little boy said he knew a song about picking flowers. They sang about grass and a meadow. So they do know a summer song after all, I thought, even if that's not what they call it here. But it was over as soon as it had begun: after the first verse about summer, we were back to the cult of personality. In the second verse, the most

beautiful of the red flowers was given to our "beloved leader." In the third, our leader was happy and smiled because he loved every child in the land.

The children did not register any of the detail in the first verse — the meadow, the grass, picking the flowers. From the very first word, their singing sounded feverish, and they became increasingly over-excited. As they reached the part about the flower-giving and the leader's smile, their singing became louder, faster, more discordant. Although the song devoted the first verse to summer, it denied the children the chance to learn about its imagery. But it also denied them the chance to learn about the act of giving. Ceausescu would often pick up children and hold them in his arms — but these children had spent several days in quarantine first to make sure they had no infectious diseases. The song required the children to suspend their critical faculties. And this was how they kept the kindergarten under control.

I COULD REMEMBER some winter songs from my childhood. The simplest was "Snowflake, White-skirted Snowflake ." I sang it to them, explained the words, and said we should all take time to watch the snow falling from the sky onto the town. Their little faces gazed up at me, expressionless. The sense of wonderment, which protects children even if it scares them, the process of learning to look and listen, which finds expression in poetic images and gives a child a frame of reference even when they are sentimental — these things were deliberately denied to them. The beauty of the fresh snow was simply not a theme for them. Romania had divorced itself from the history of emotion. It was forbidden to implant metaphors — such as "white-skirted snowflake" or "living in the clouds" — in the children's minds. In fact, the snow song was too quiet for these children, whose young minds had already

been warped. For them, sensation only began when they stood to attention and bellowed. They were not allowed to perceive themselves as individuals and use this as a starting point to explore themselves and their surroundings, which is all part of socialisation in a civil society. This denial of all that is personal had a devastating impact later, for every single person was completely ill-equipped to cope with life. And this was exactly what the state wanted: weakness should begin at the point where a person's skin is too thin. The regime offered an escape route out of weakness: toadying to the powerful, the denial of the self, and obsequiousness as a chance to get ahead. Self-sustaining sensory perceptions which did not require this kind of escape route were to be stamped out all together.

On my first day in the kindergarten, I told the children to put on their coats, hats and shoes, as we were going outside in the snow. The director heard the noise coming from the cloakroom. She tore open her office door. We've been singing a song about snow, I said, and I don't see why we should sit inside while I tell them about the snowflakes falling. We'll be back in the classroom in half an hour. "What do you think you are doing?" she screeched. "That song isn't on the curriculum!" We had to go back to the classroom. We had games, then break, then lunch, and then the anthem again.

The next morning, I asked the children first of all whether anyone had watched the snowflakes "which live in the clouds." It seemed that I was the child, for I had done so. To give myself courage to face the day, I had even sung the song silently in my head on the way to work. Tentatively, I asked them whether they could remember the song from yesterday. A little boy said, "Comrade, we have to sing the anthem first." "Do you want to, or do you have to?" I asked. "We want to," chorused the children. I relented and let them

sing the anthem. And like the day before, they sprang to attention and formed a semi-circle, pressed their arms to their sides, threw back their heads, raised their eyes, and sang at the top of their voices. Finally I said, "That's enough, let's try and sing the snow song now." At this, a little girl said "Comrade, we have to sing the anthem all the way through." It would have been pointless to ask again whether they wanted to, so I just said, "You'd better sing it all, then." They sang the rest of the verses. The semi-circle broke open, and all the children went back to their places. All but one little boy, who came up to me, looked me in the face and said "Comrade, why weren't you singing too? Our other comrade always sang with us." I smiled, and said, "If I sing, I can't hear whether you are singing properly or not." I was lucky; my little watcher hadn't expected this answer. Nor had I. He ran back to his table. He was not one of the four higher beings in the group. For a moment, I was proud of my lie. But the fact that I had been forced to lie made me feel uncomfortable for the rest of the day.

I felt physical revulsion every morning I went to work at the kindergarten. The children's constant surveillance paralysed me. I realised, of course, that I could not possibly expect five-year-olds to make a conscious choice to sing the snow song instead of the party anthems. But they might instinctively unconsciously, have preferred the snow song instead of the bellowing and standing to attention. It was forbidden to give the smallest children, the three-year-olds, anything personal to take away with them. But subjectively, this might still have been possible. But with the five-year-olds, it was already too late, even subjectively. This became increasingly apparent as the days passed. The fabric of their personalities had been abused, and this abuse had been internalised. They had become dependent on it. The destruction of these five-year-olds was complete.

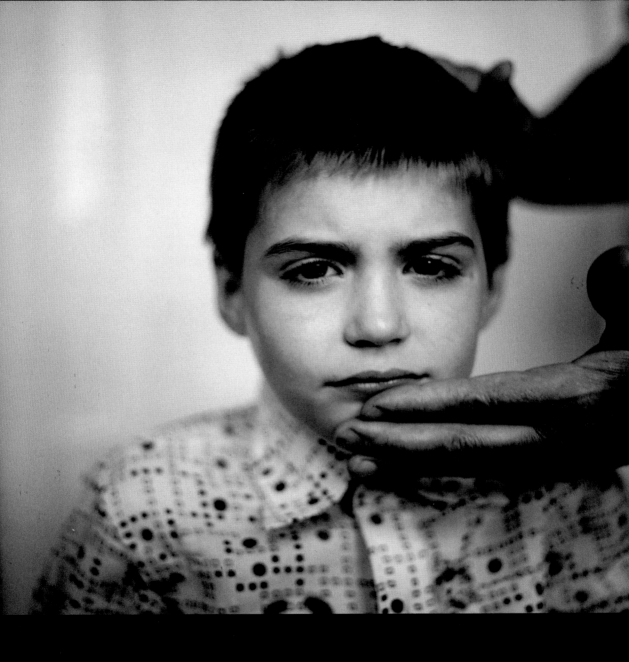

3. Irina

...WAS ONE PART OF THE STORY. The cane did the
...All the children – except for the higher beings, who were
...spared on account of their party heritage – automatically
...ed away from me every time I approached them. I didn't
...the cane in my hand, but they were so used to being
...en that they would squint up at me, their faces twisted
...fear, and beg, "Don't hit me, please don't hit me." And
...hildren who were out of reach would shout, "Now it's
...turn, now it's your turn!"

...never used the cane, not once. As a result, I was quite
...le to get the children's attention for five minutes at a
...no matter how much I begged, reasoned with them or
...d. Anyway, it was too late for all that. Ordinary words –
...atter what tone of voice was used – were no longer a
...s of communication. Only the cane broke through the
...e induced by the empty phrasemongering.

...he children tried to force me to satisfy their need to be
...en. They felt bereft, abandoned, hysterical, empty,
...use I wouldn't beat them. Crying under the cane was
...nly time they experienced themselves as individuals. It
...d them out of the collective.

...assing the half-open doors of the other classrooms,
...d hear the swish and smack of the cane, and the children
...g. For the director and my colleagues, who beat and
...ps did other things to the children who wanted to cry,
...an incompetent. To some, I was unwilling, and to the
...s, I was unable to use the cane.

...ut I was less and less able to cope with myself as well.
...rmined not to become like the others, and unable to
...nue as I was – this conflict was impossible to resolve.
...two weeks, I resigned.

...he dictatorship lasted for fifty years. The dictator was
...in 1989 and his bones lie in the cemetery. But his

people have survived. The ways of thinking which are the ha...
mark of a civil society are still a rarity in Romania. A...
the presidential elections in December 2000, 35 percent
Romanians voted for an ultra-right extremist who wa...
Ceausescu's crony until 1989. He campaigned on an an...
semitic, nationalist, Stalinist ticket. His anti-poverty pro...
gramme consists of isolation from the West, labour cam...
for "vagabonds and beggars," and more powers for the arm...
and secret police. The socialist utopia of "equality fo...
all within the collective" still exists today. The fifty years ...
egalitarianism based on poverty and the erosion of th...
belief in the intrinsic value of the individual are deep...
rooted in people's minds. Respect for the life and the righ...
of the individual must be learned, but poverty is not a goo...
school within which to teach this lesson.

The question which I had to ask myself so often in Roman...
is still relevant today: how much is a human life worth? A...
much money as it costs. But most people have no mone...
The state still has nothing to offer them, and they can gi...
nothing to the state. For poor people, life is over very quick...
Because they have no money, they have no choice but t...
pay for everything with a handful of life. Without any choice,...
is soon spent.

There is a Romanian proverb which says: A good pers...
is worth as much as a piece of bread. This doesn't s...
much for the value of the individual, but it says an awful l...
about the value of bread. This kind of folk wisdom on...
evolves where there is no bread but a great deal of hunger...

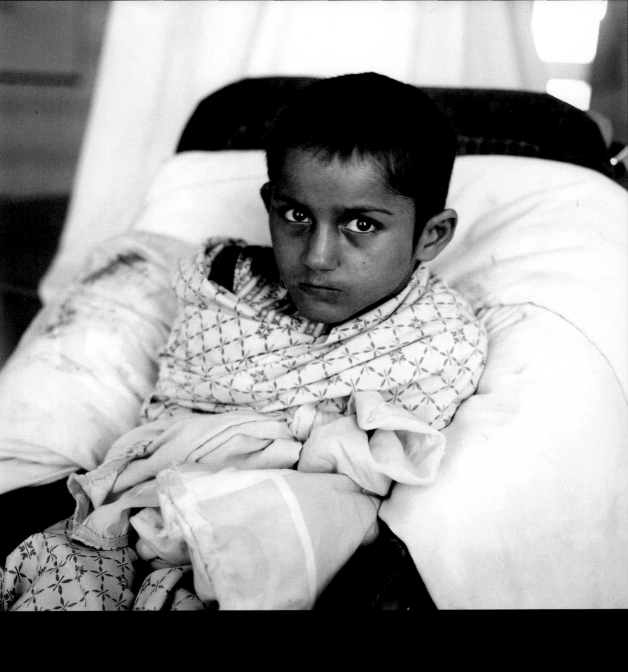

4. Sebastian

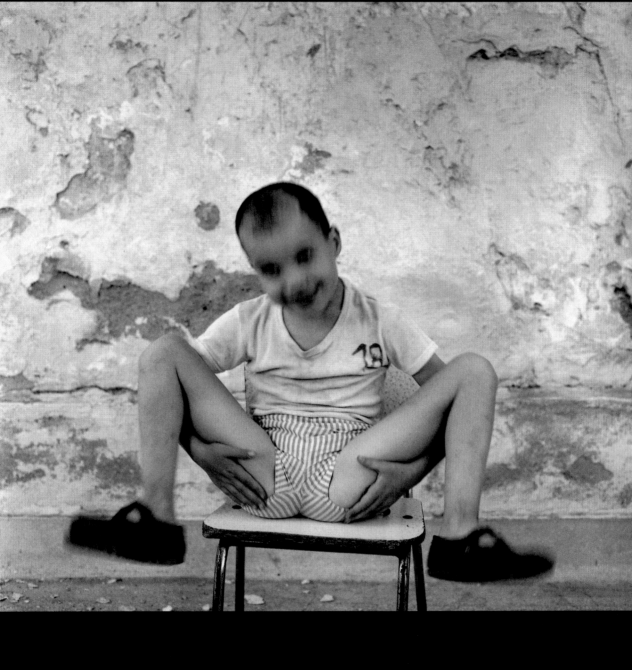

5. Valerica

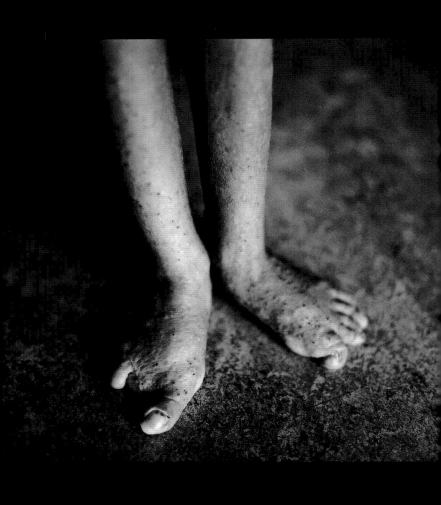

6,7. Claudia

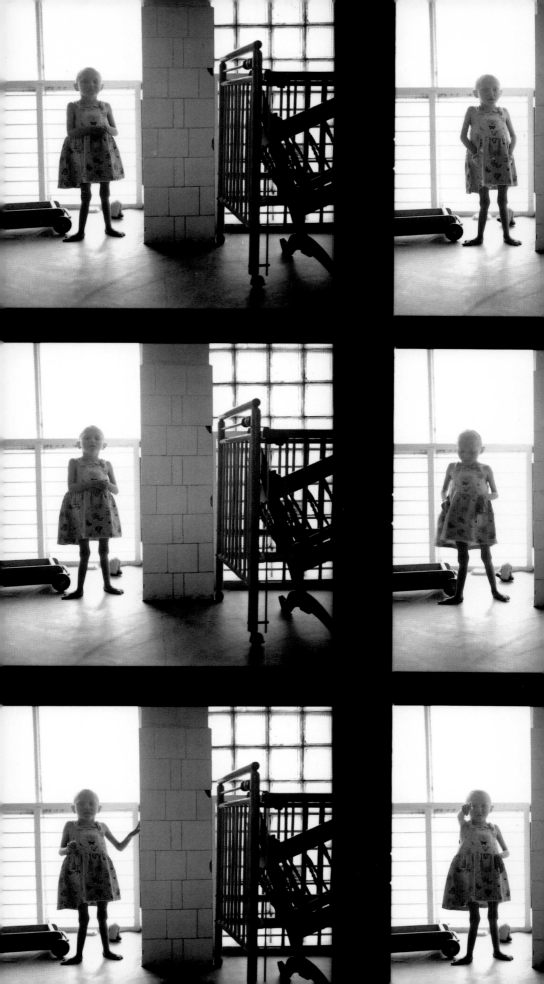

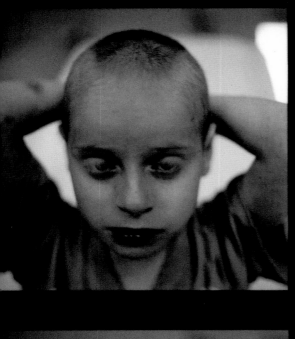
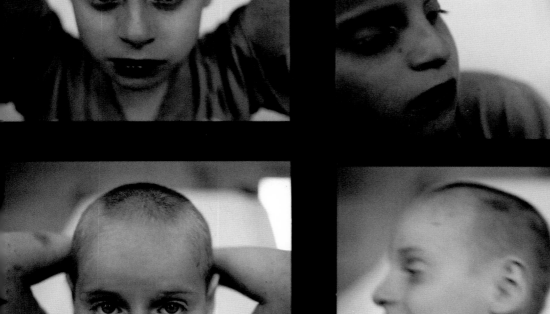
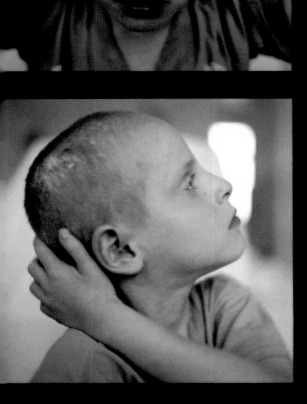
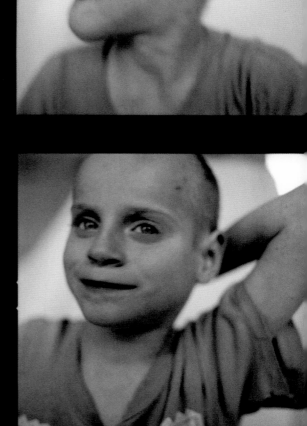

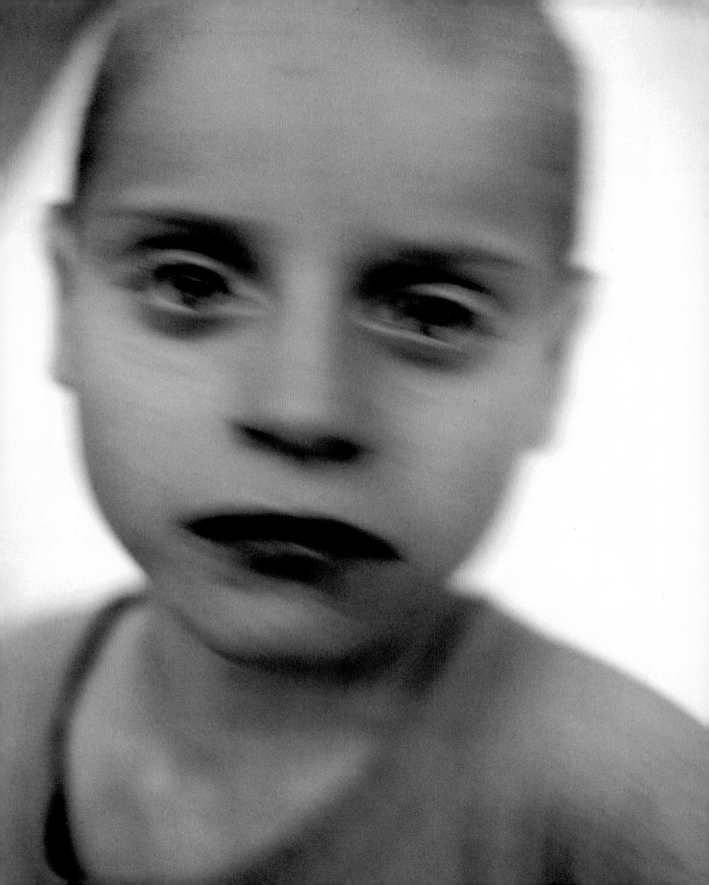

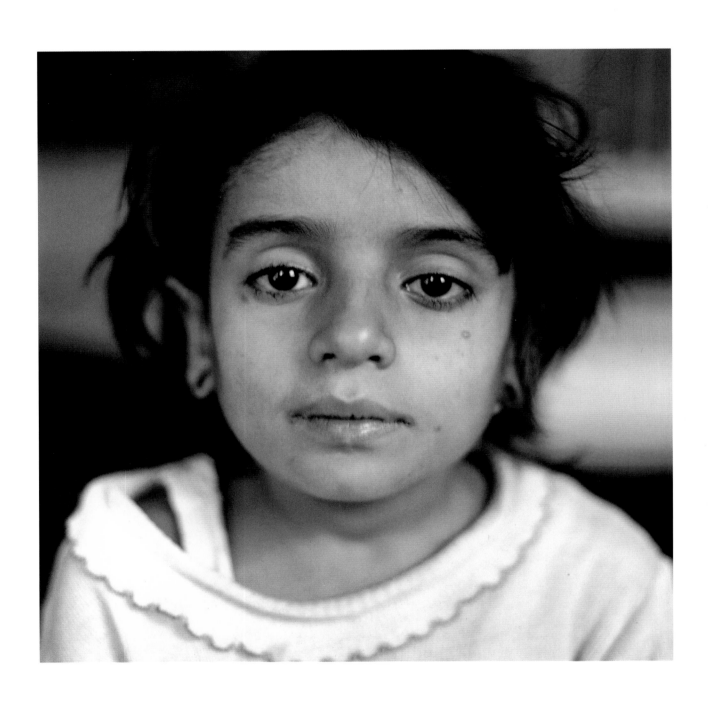

8,9. Cornelia 10. Mirabela

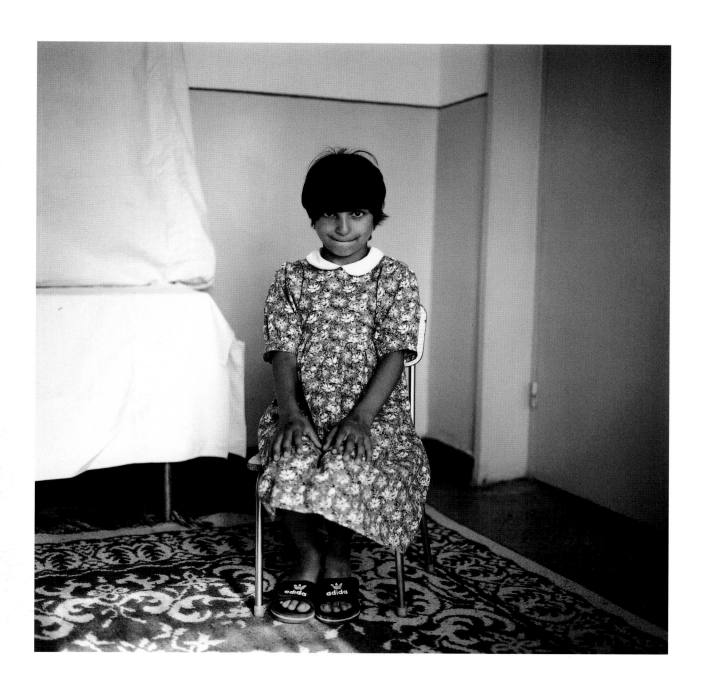

11. Ileana

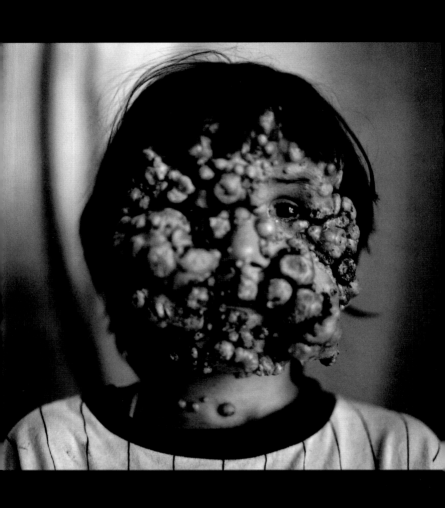

12. Mariana 1996

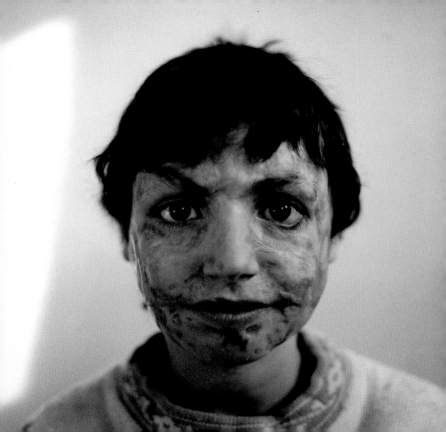

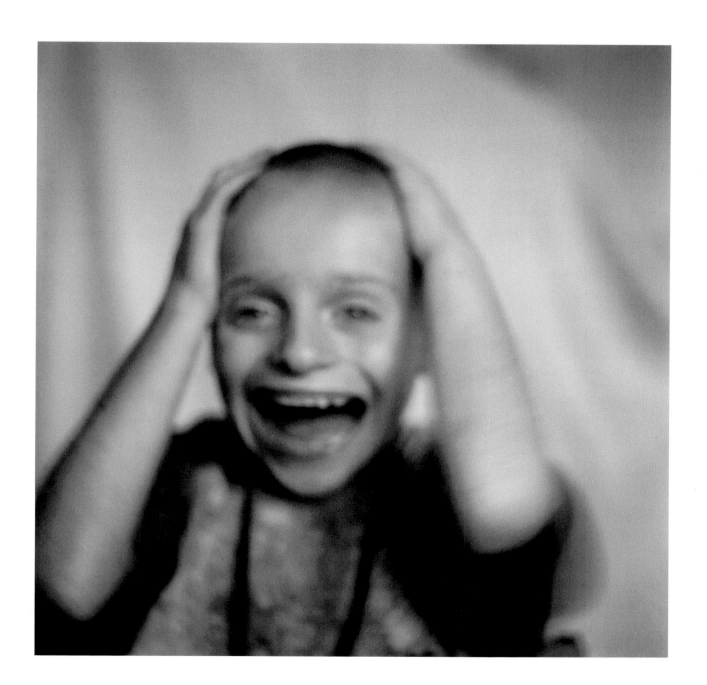

14. *Cornelia*

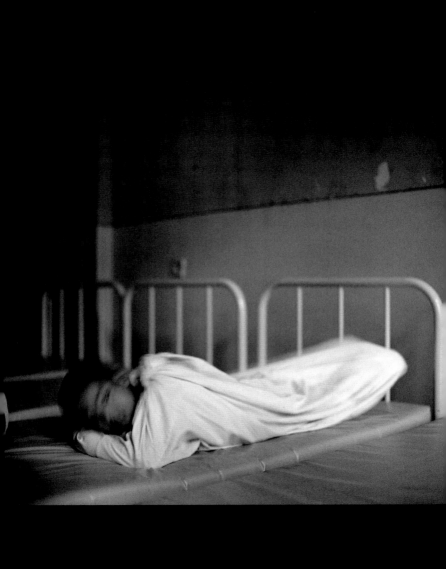

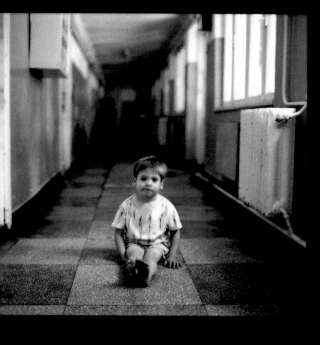
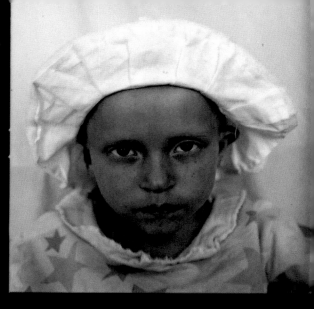
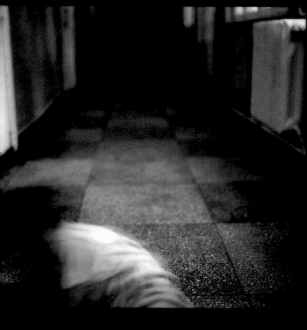
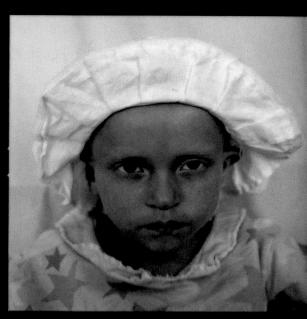
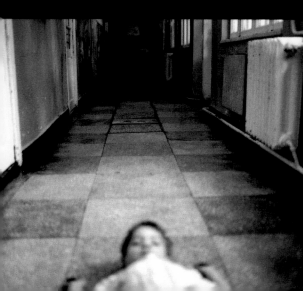
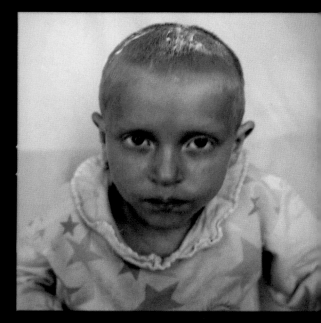

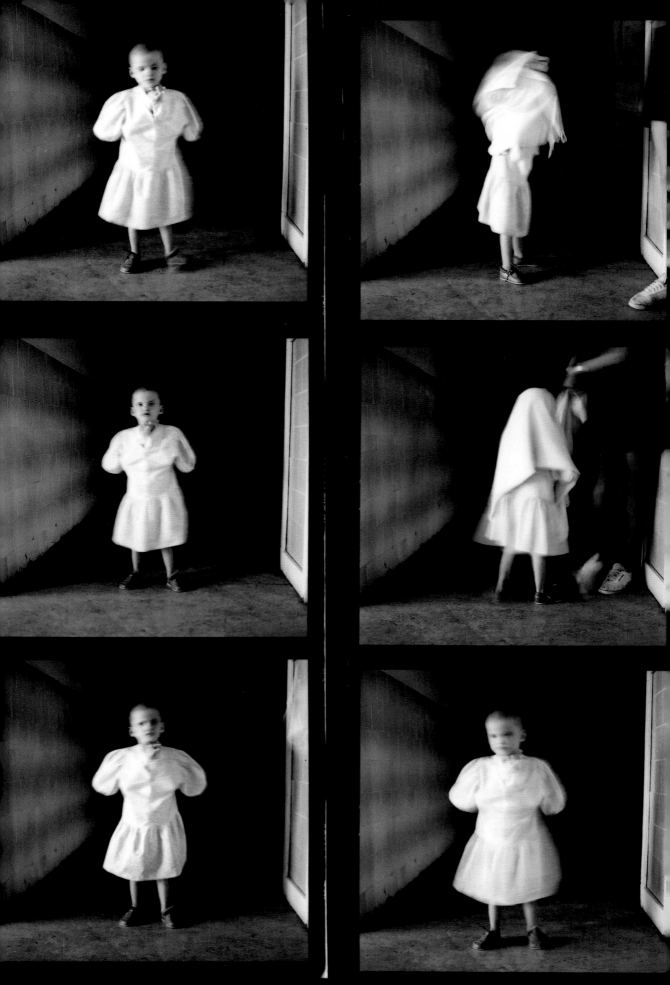

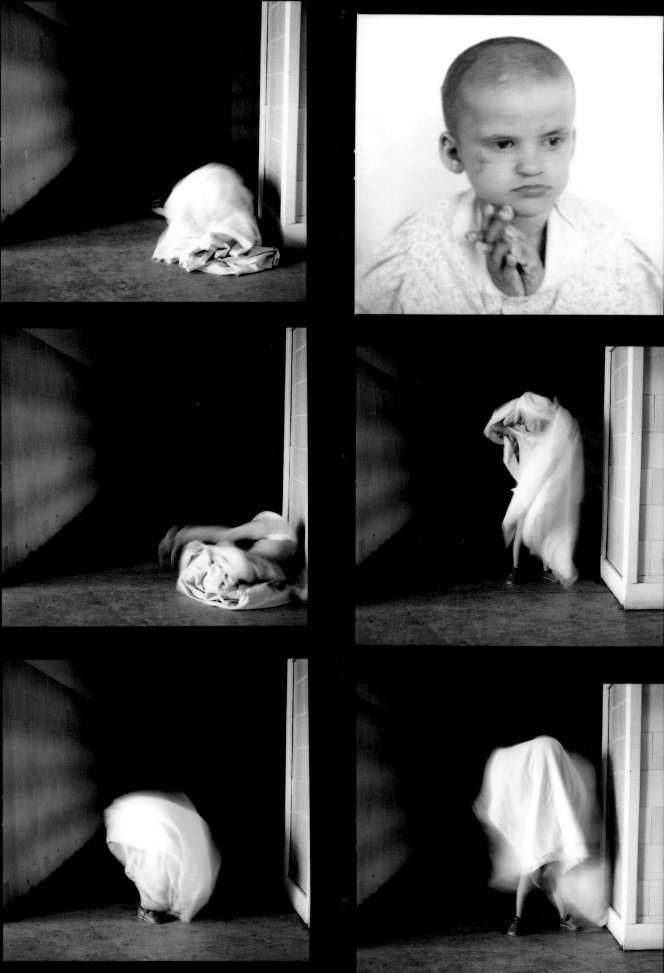

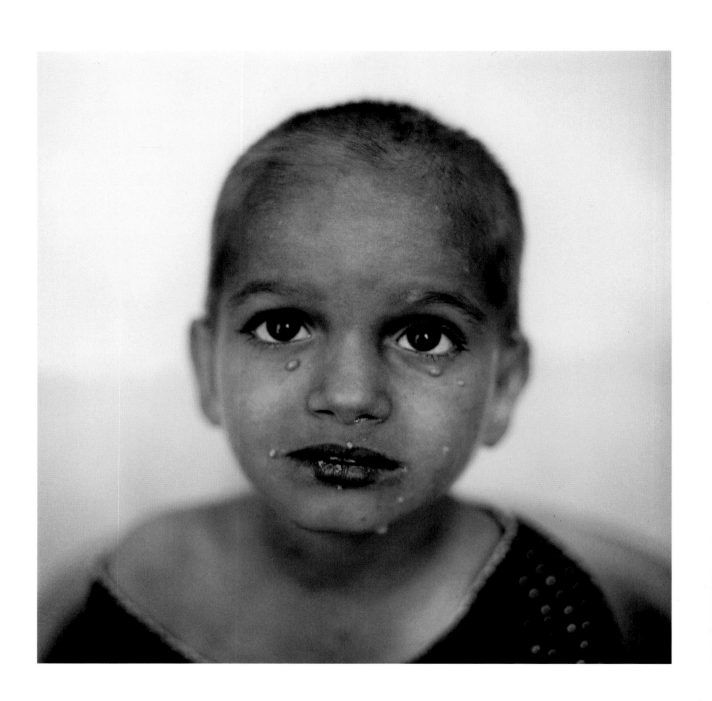

18. Carmen 19. Ionut

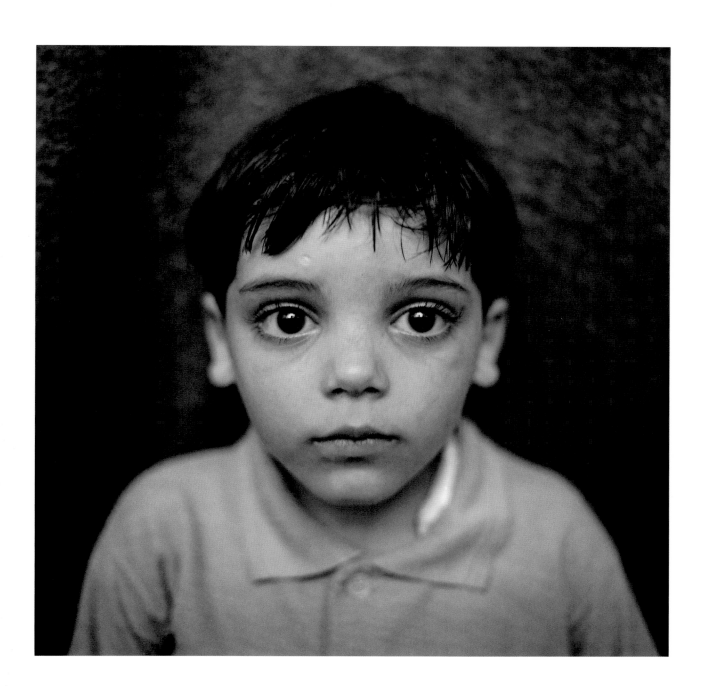

20. Claudiu

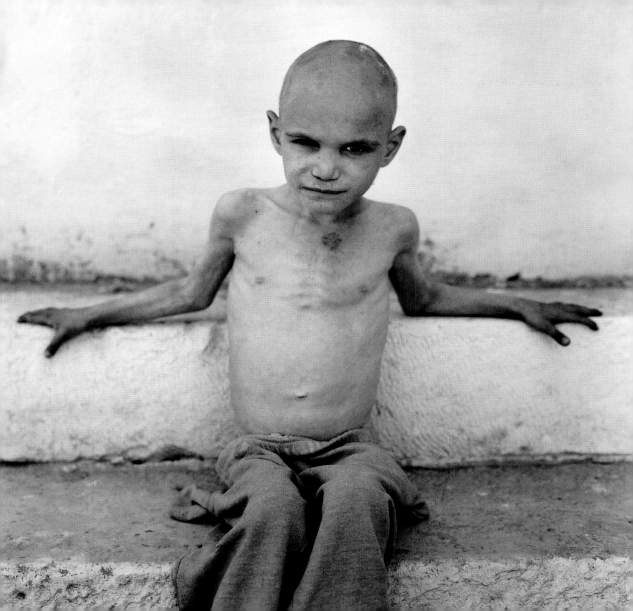

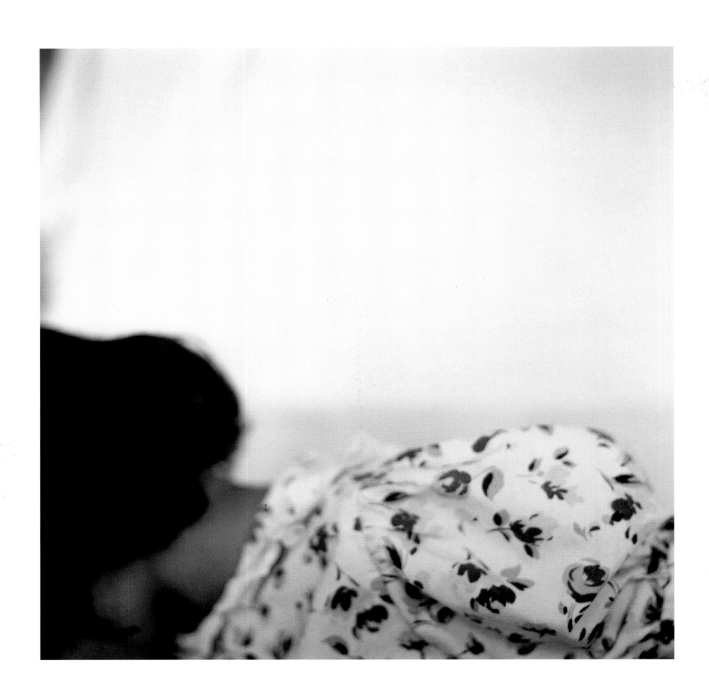

22. Oana

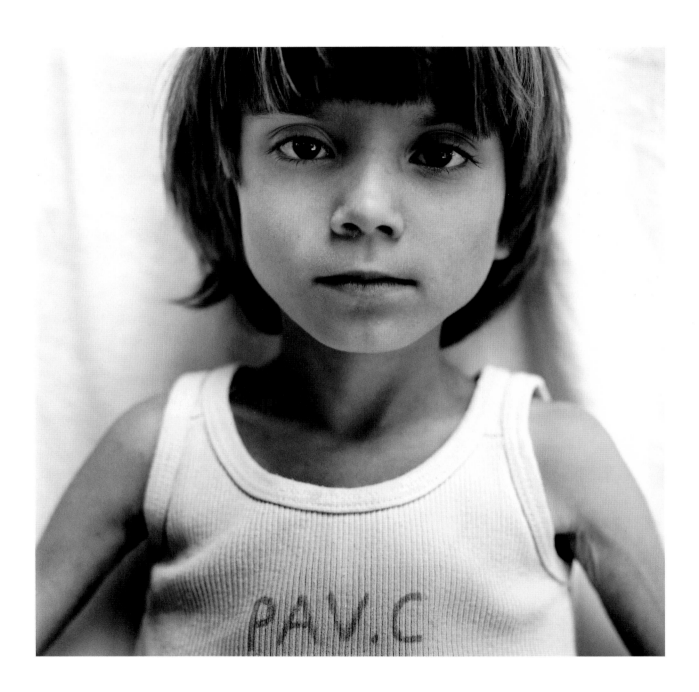

23. Ana-Maria

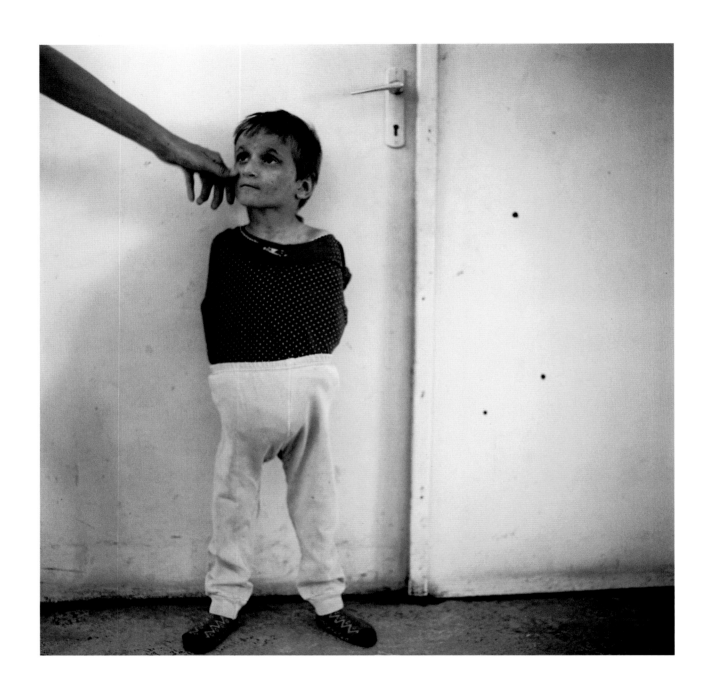

24. Florin

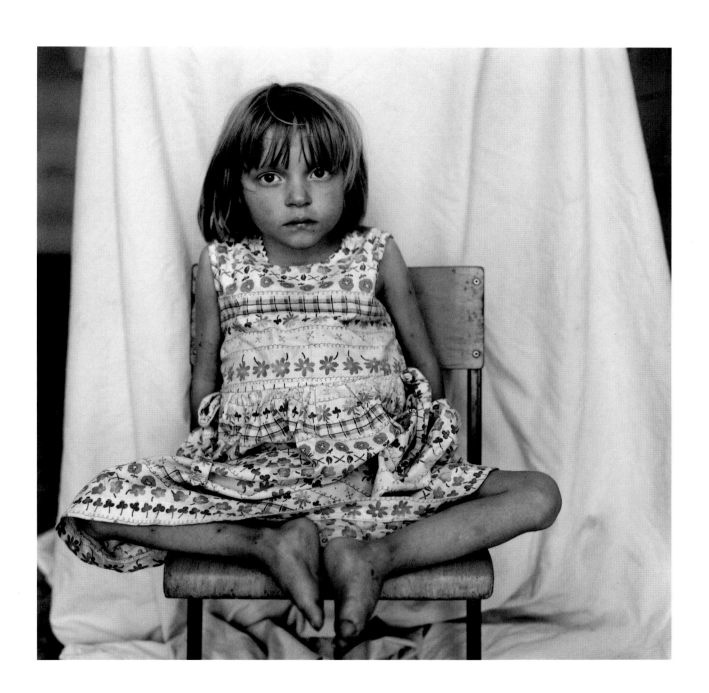

25. Cornelia

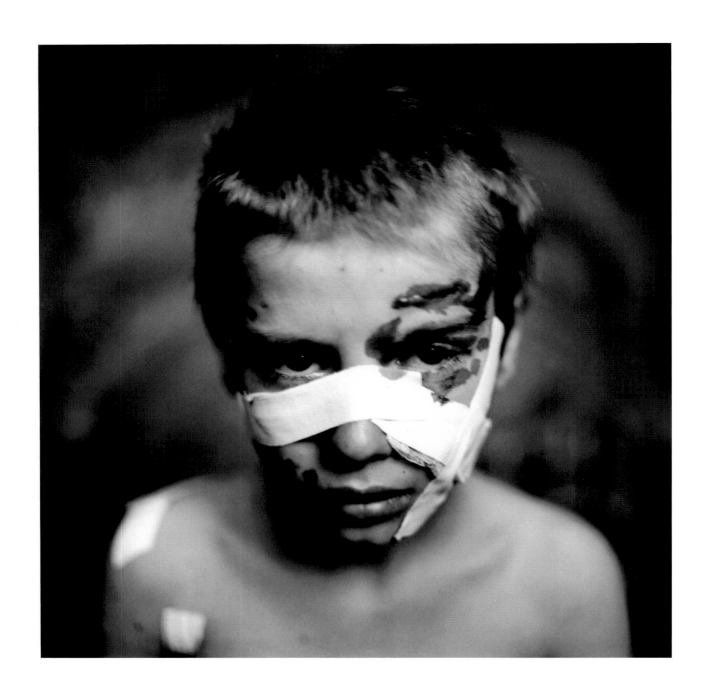

26. Mihai

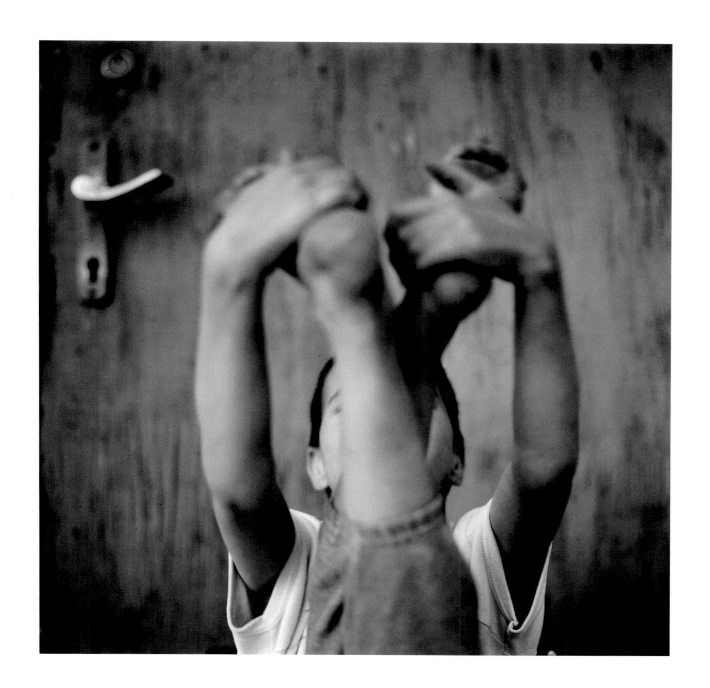

27. *Valerica*

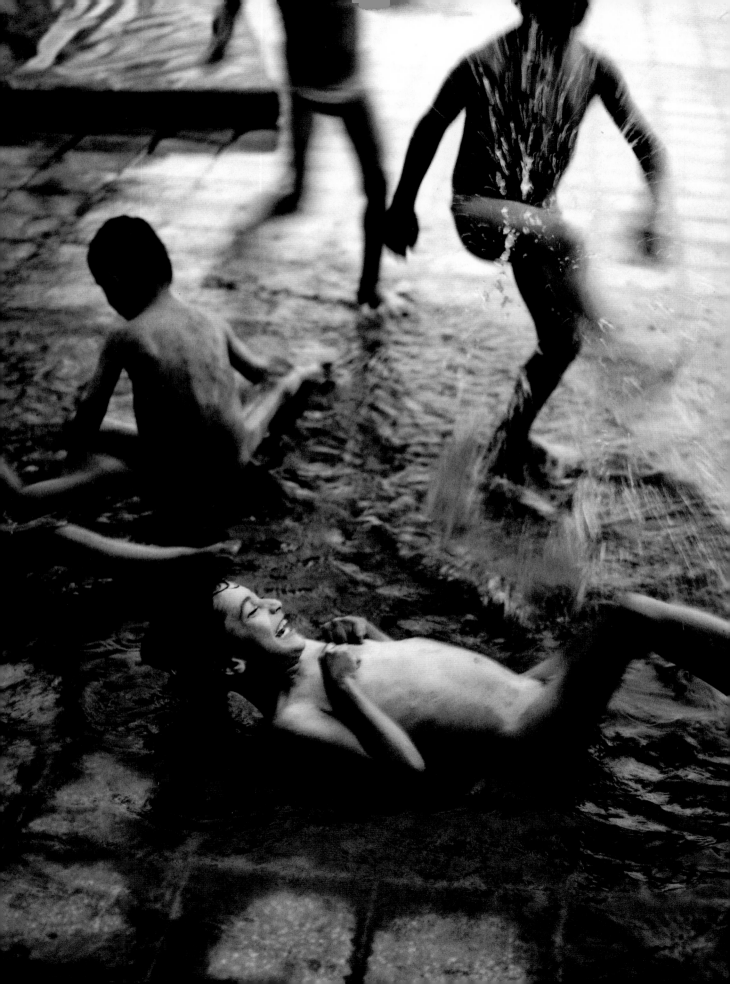

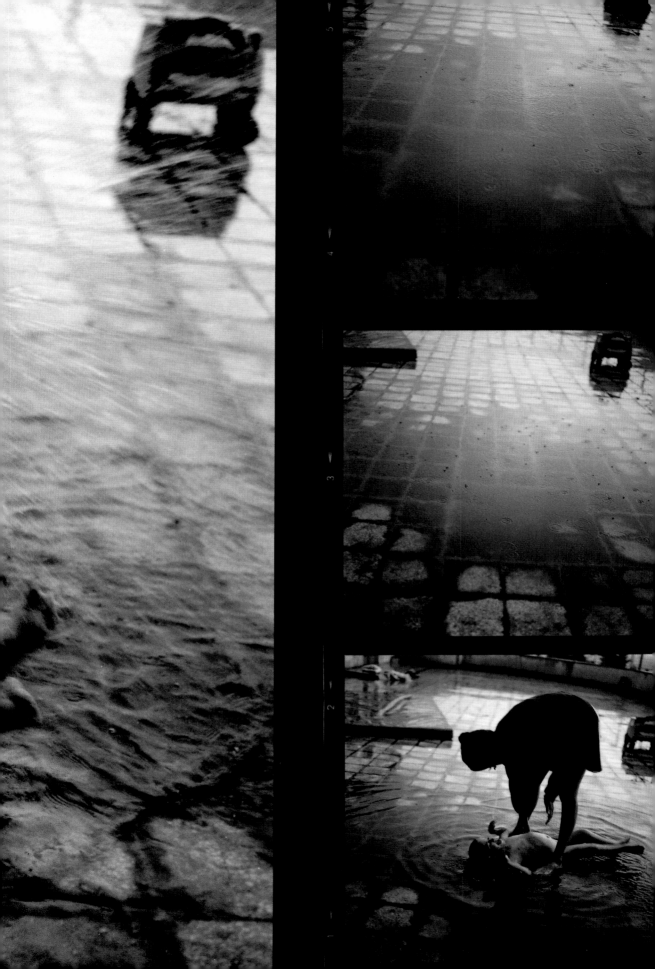

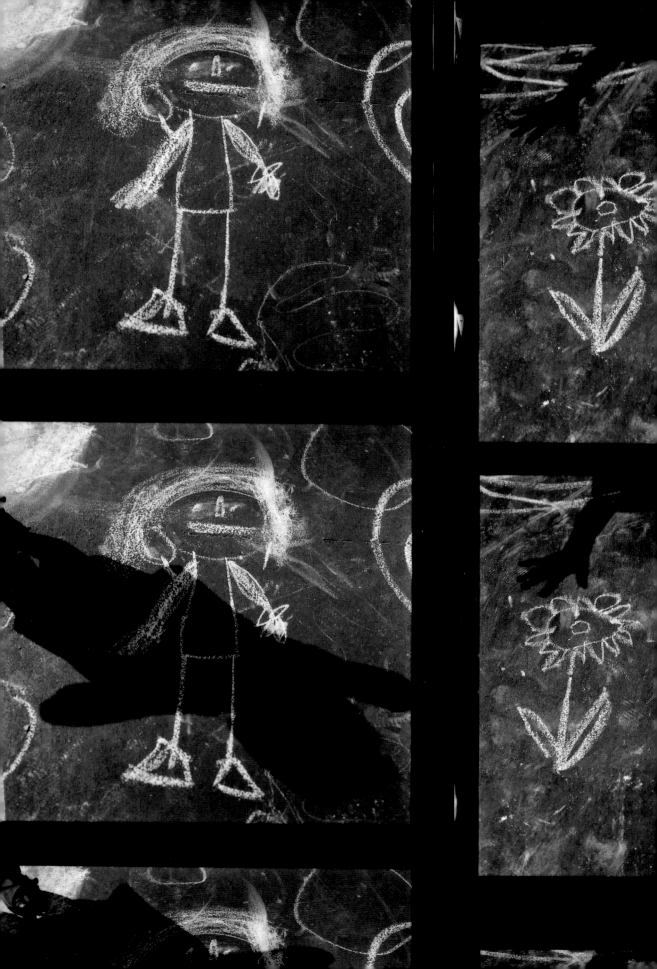

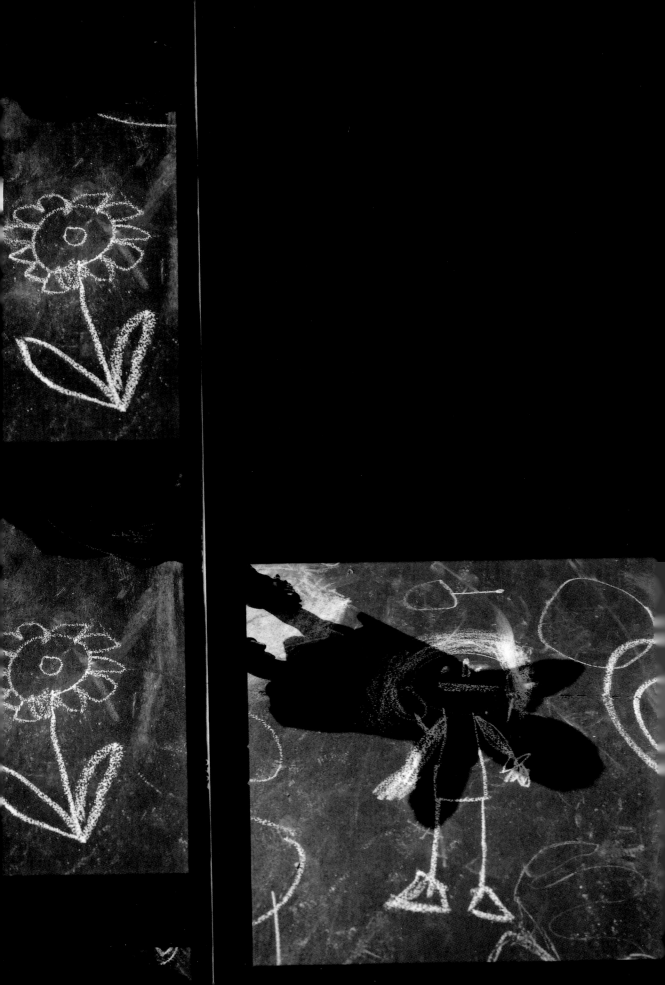

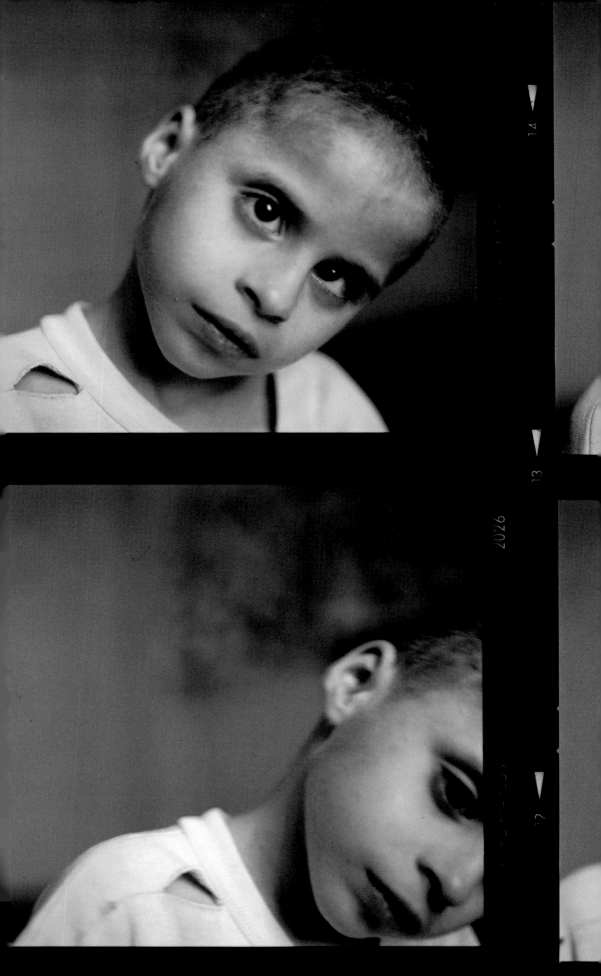

2026

2026

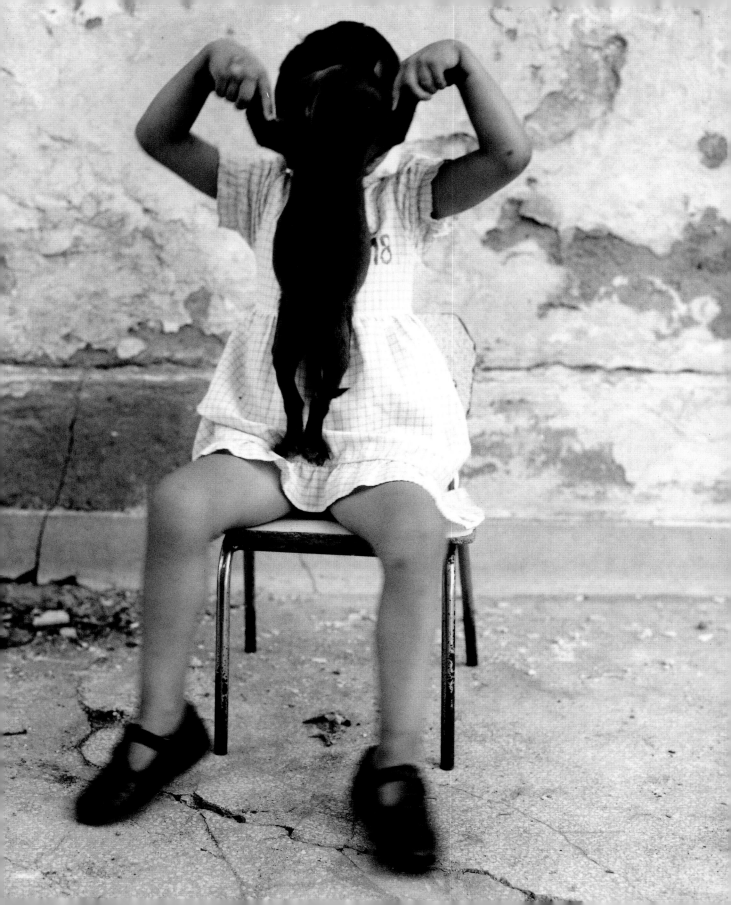

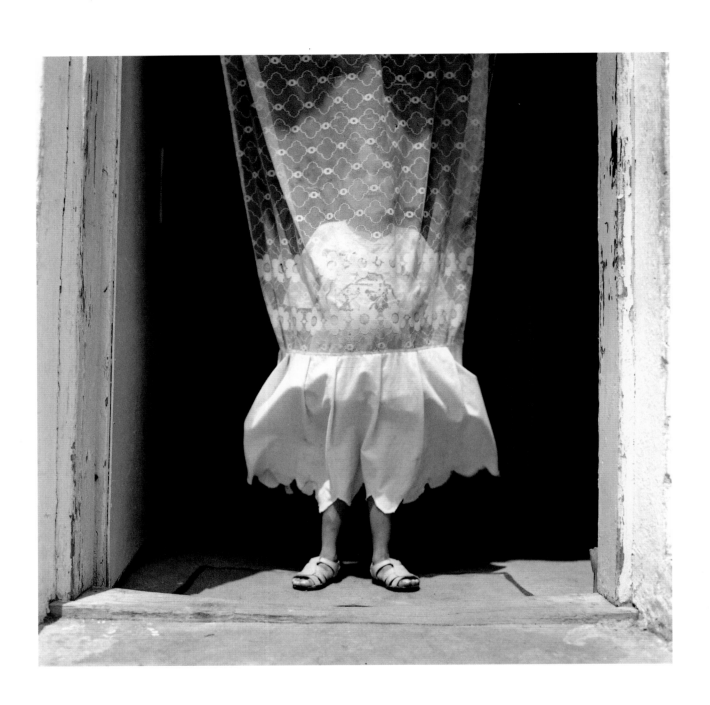

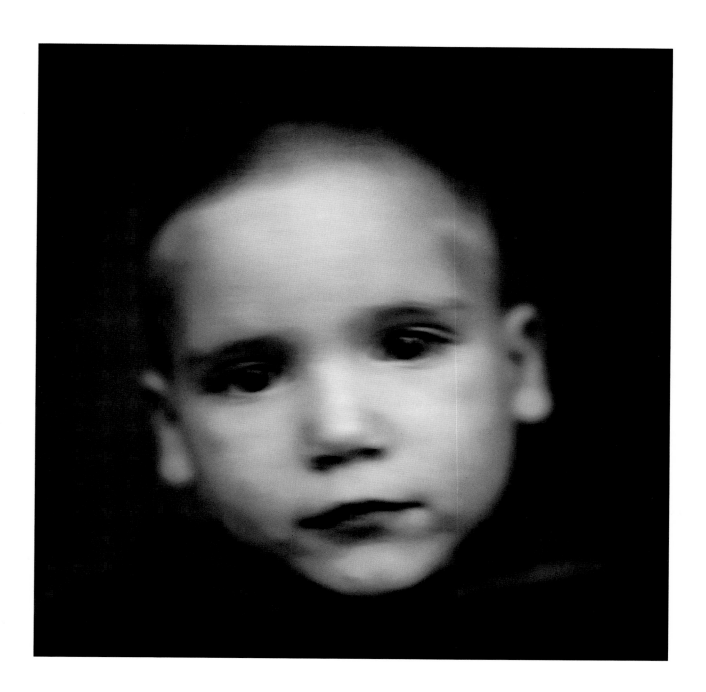

35. Georgiana

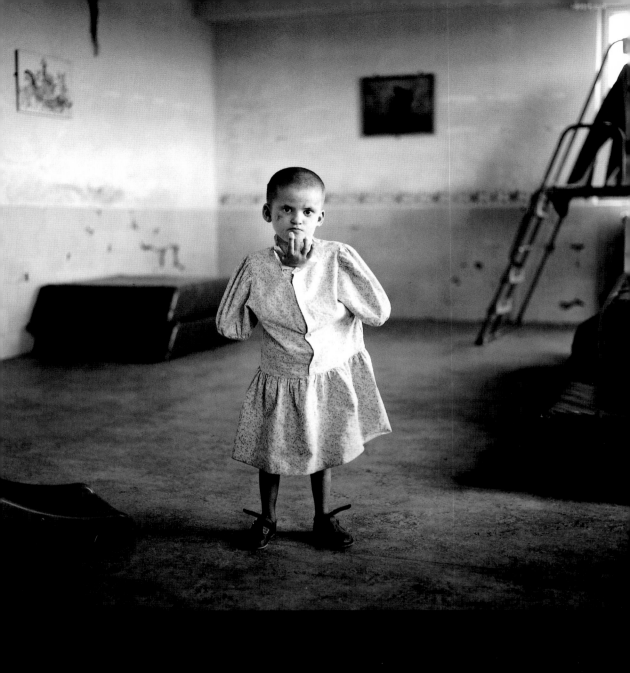

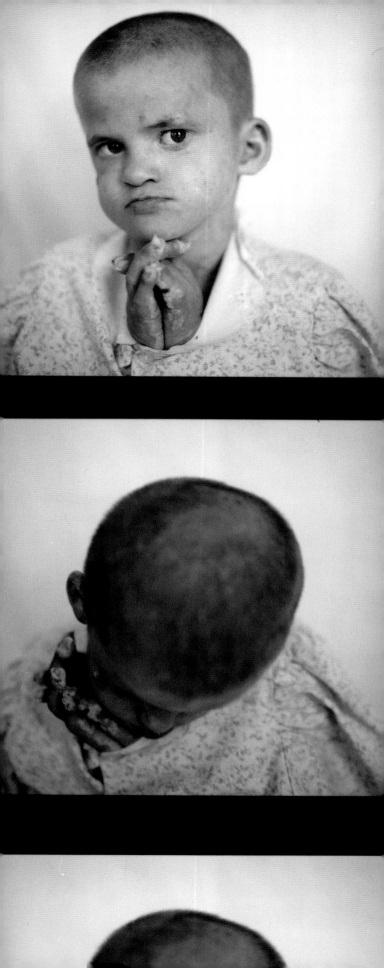

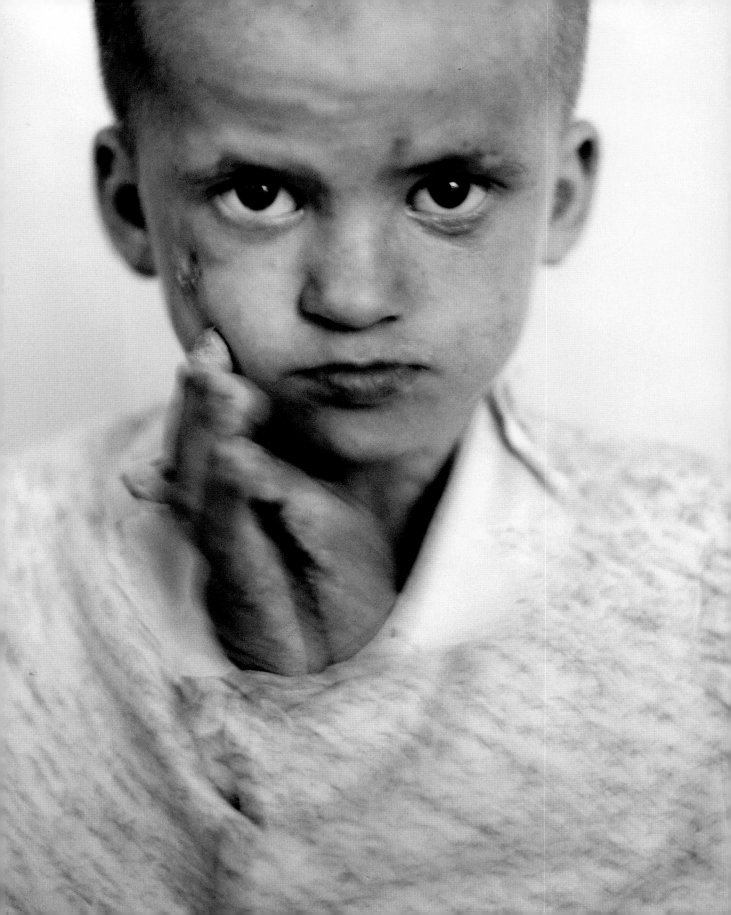

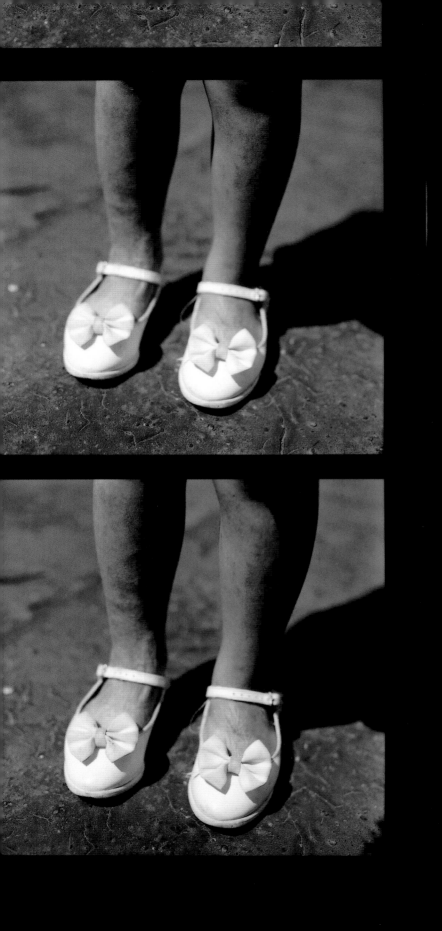

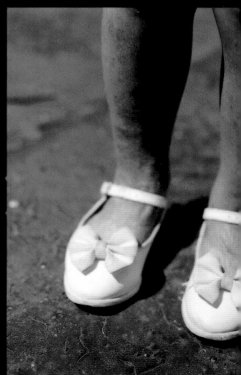

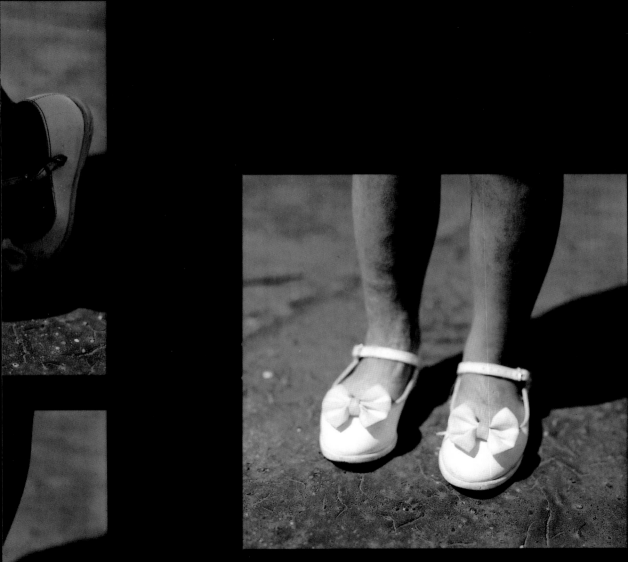

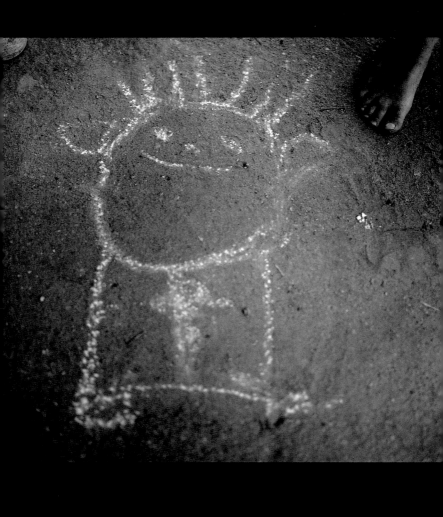

37,38. Carmen 39. Sofia 40. Galati

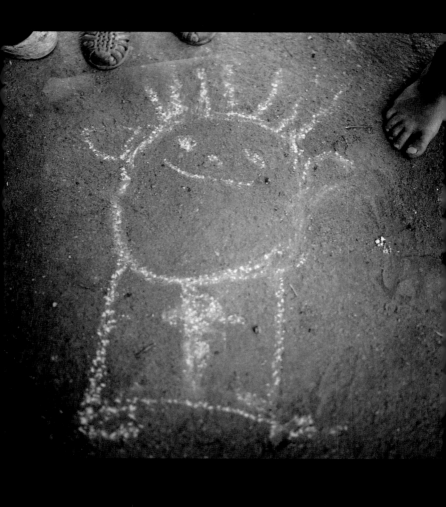

41. Galati

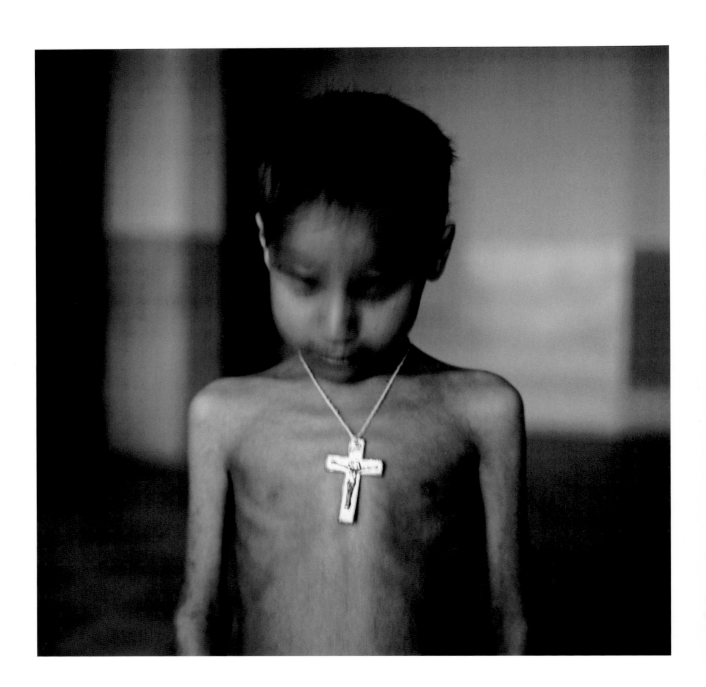

42. Nicu

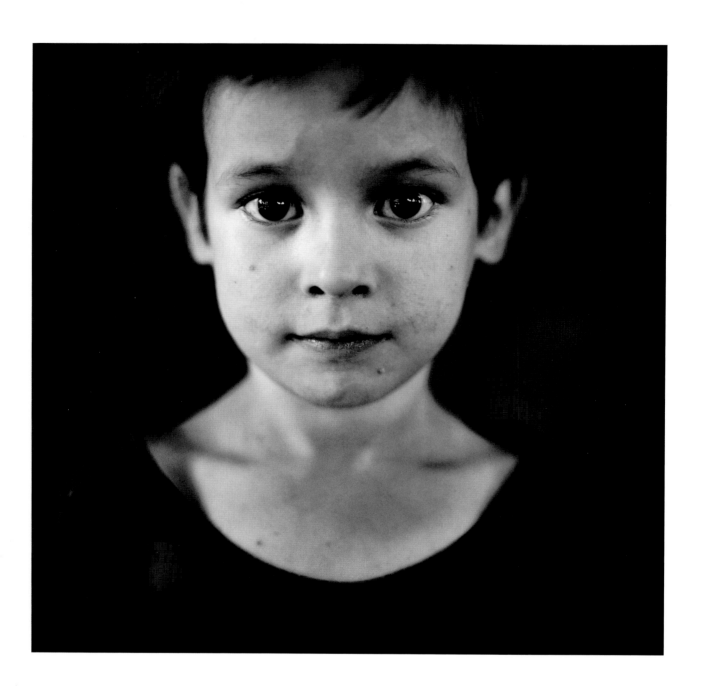

43. Simona

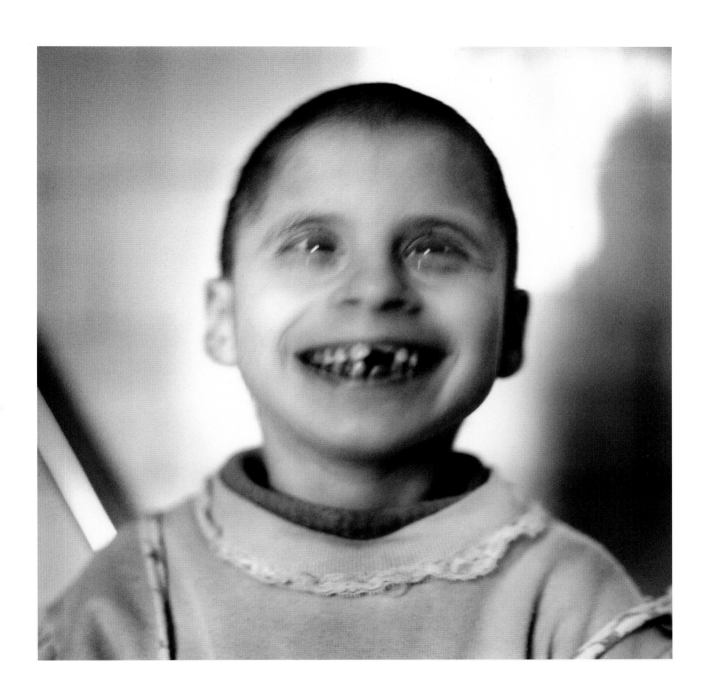

44. Tita

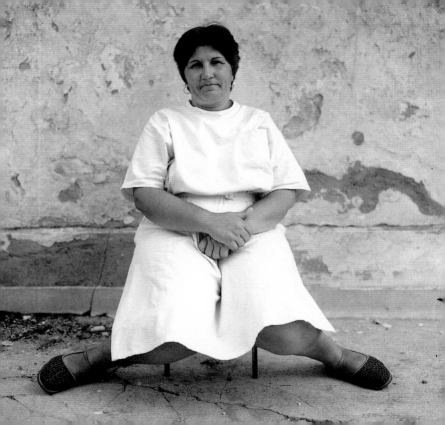

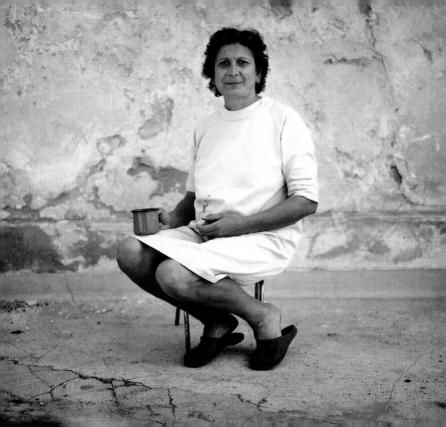

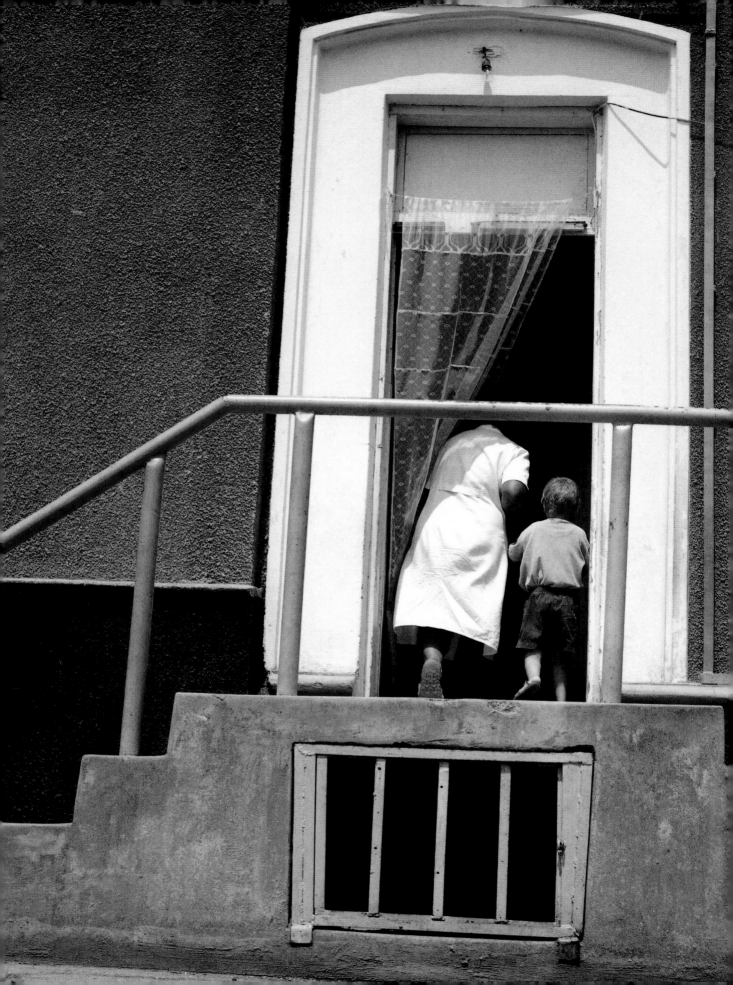

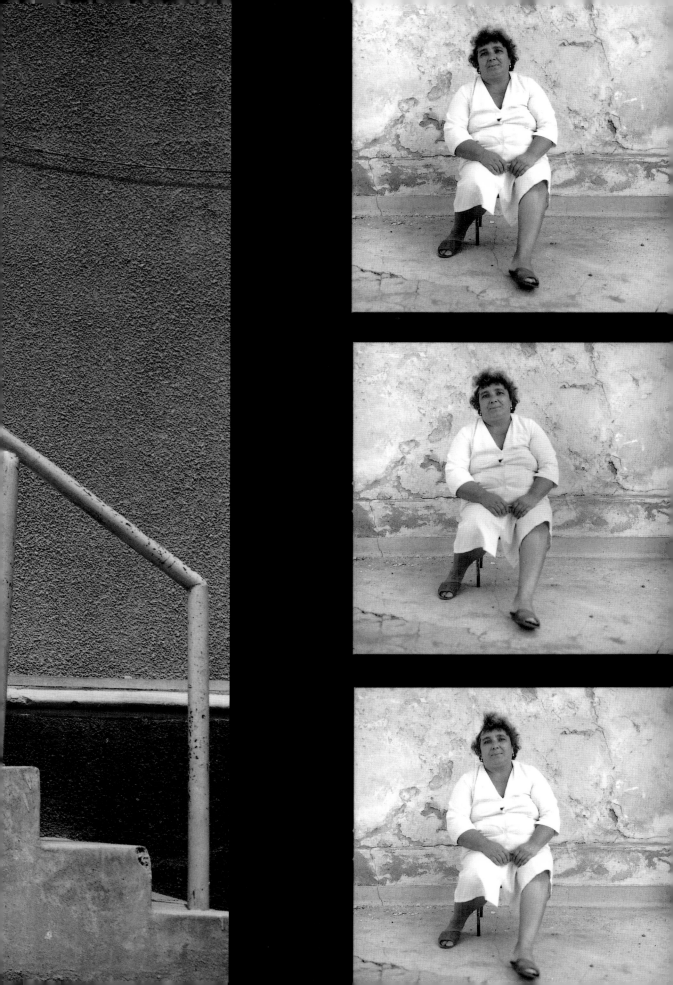

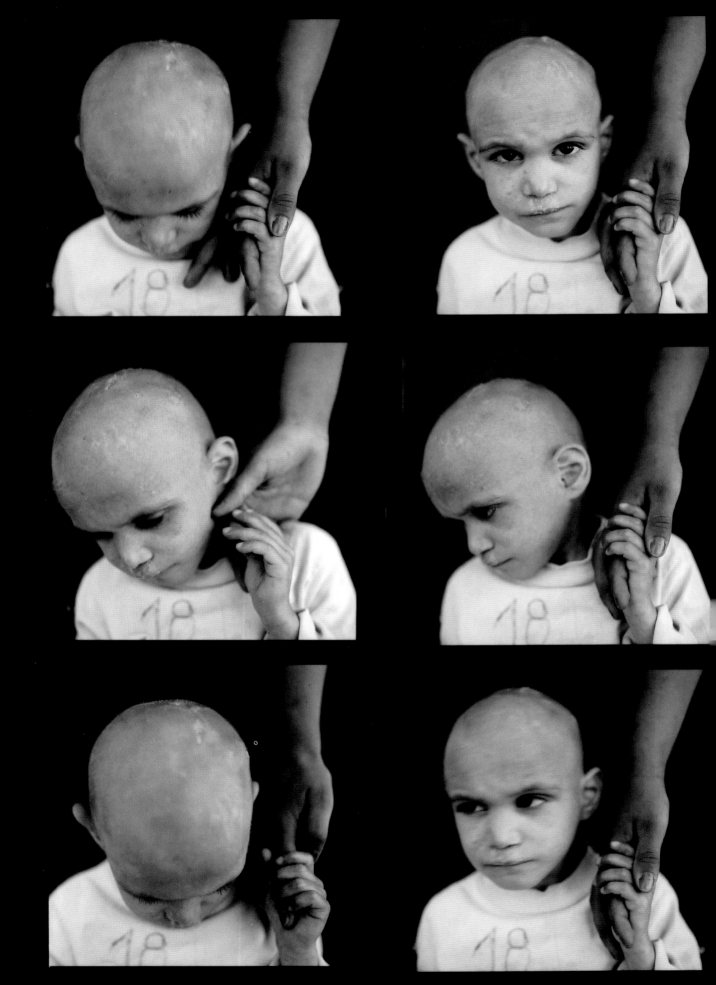

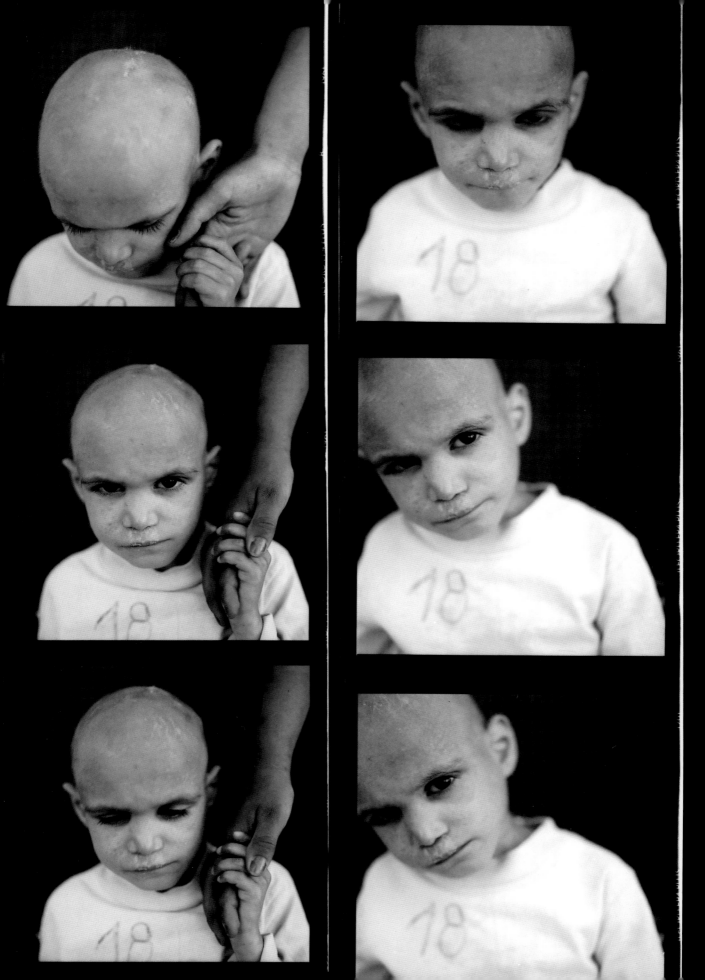

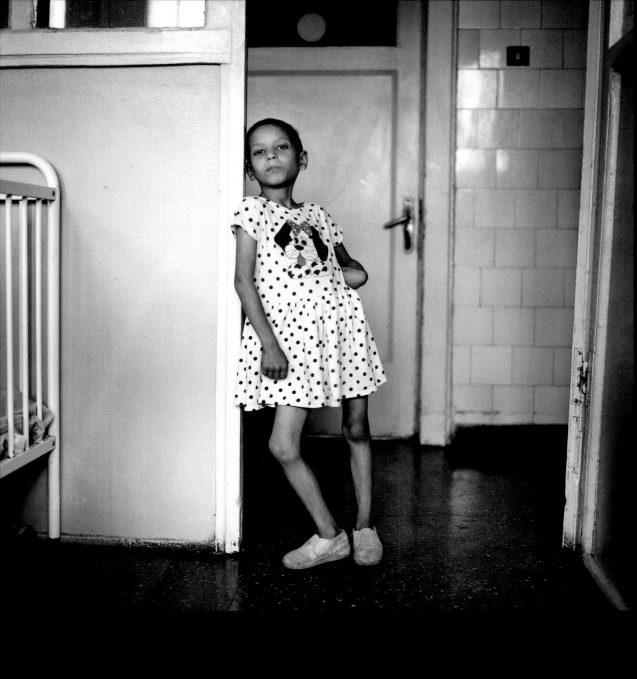

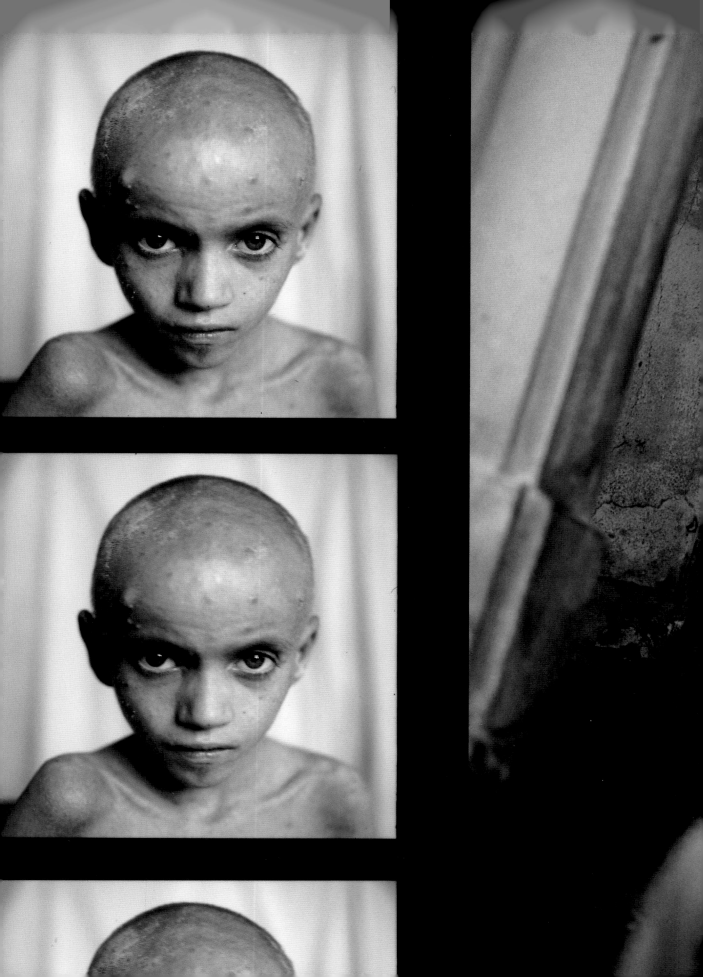

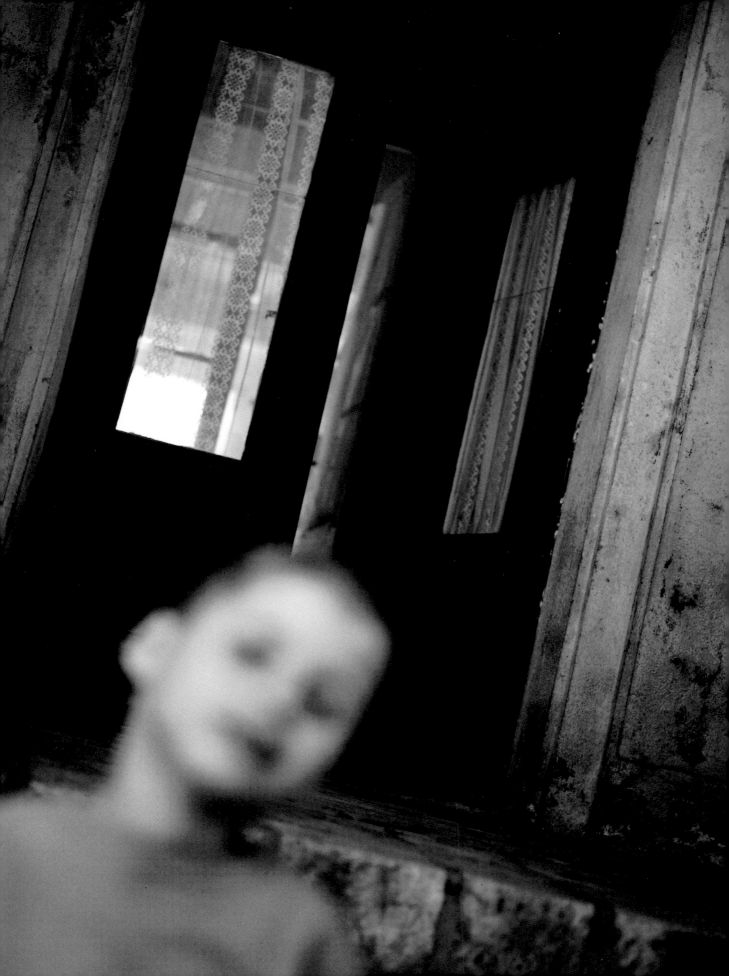

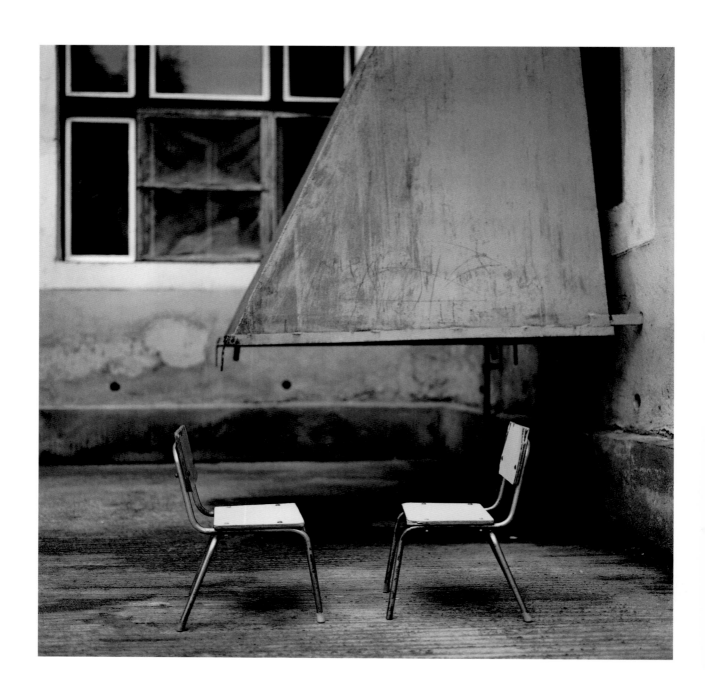

51. Florin 52. Tita 53. Targu Mures

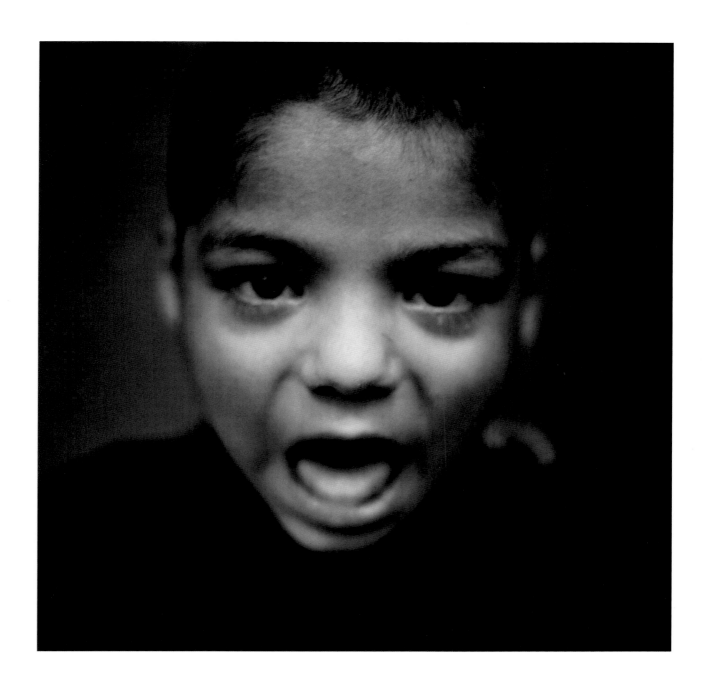

54. *Vervel*

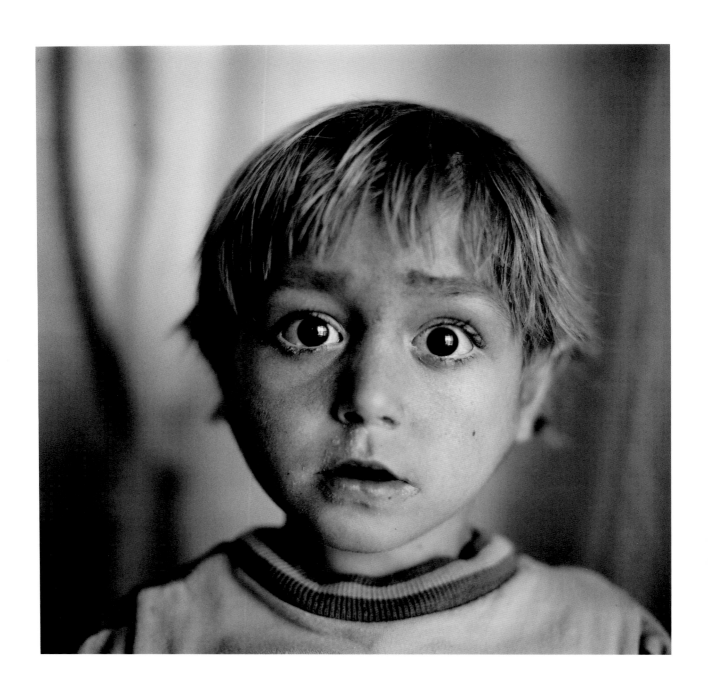

55. Daniel

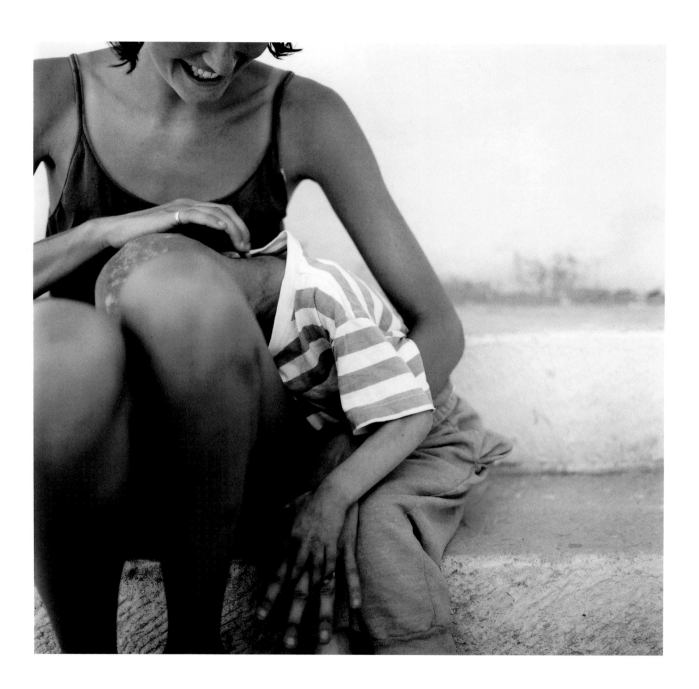

56. Laura / Lisa

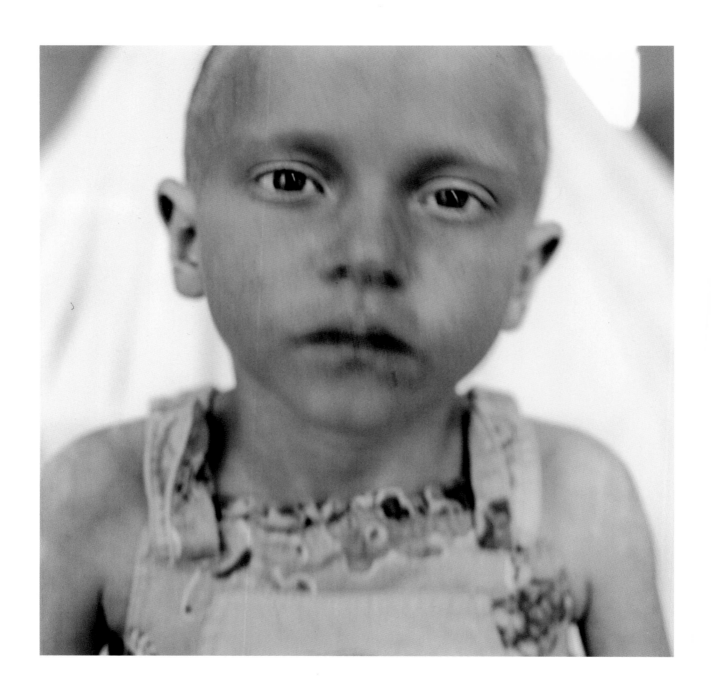

57. Claudia

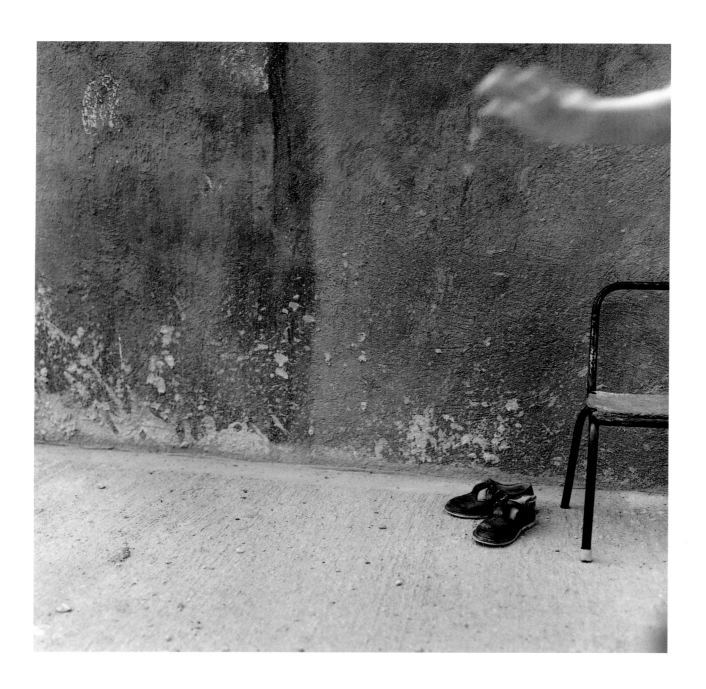

58. Iliaz

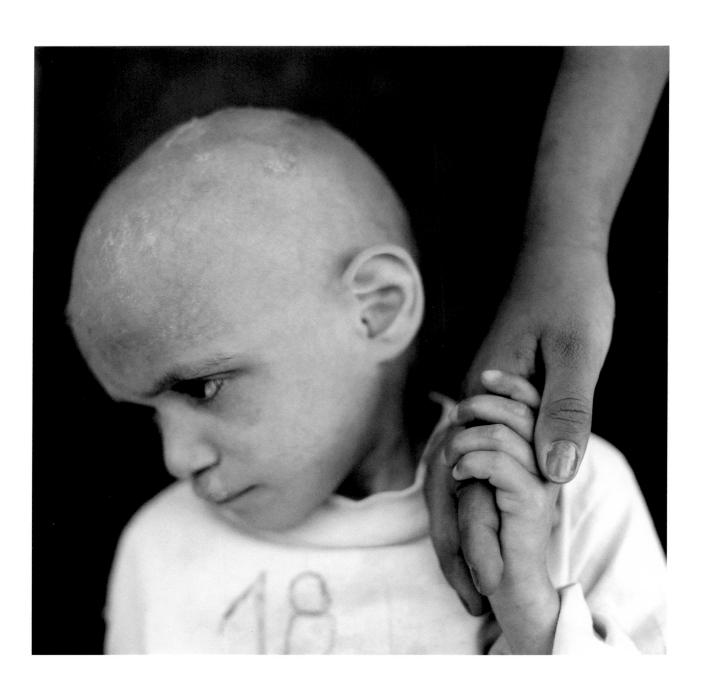

59. Laura

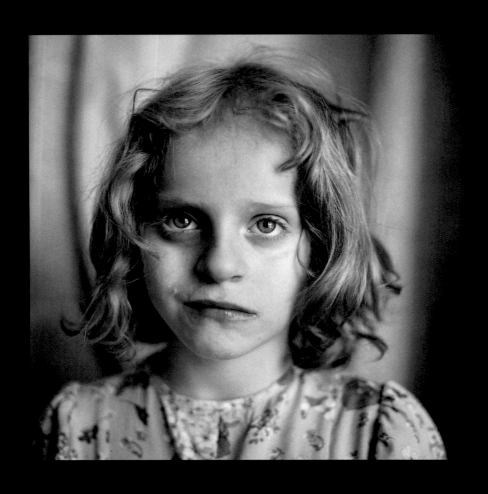

60. Cornelia

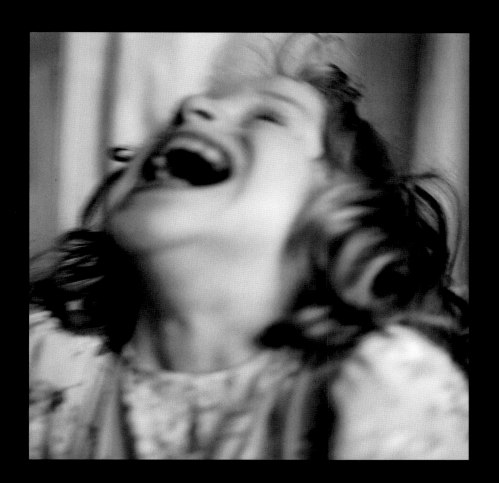

61. Cornelia

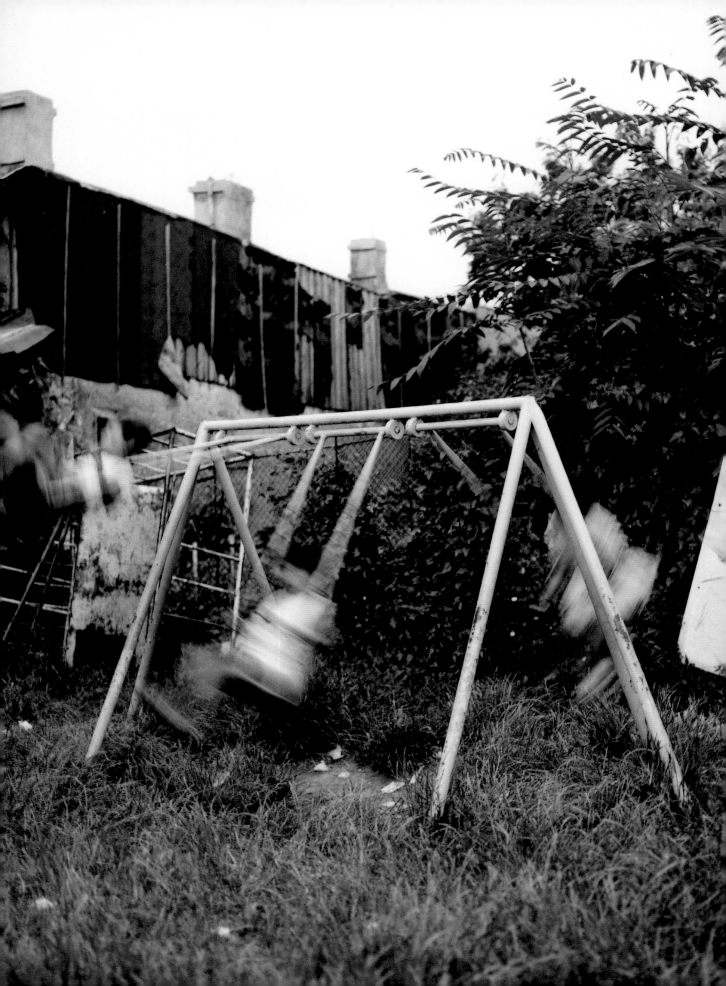

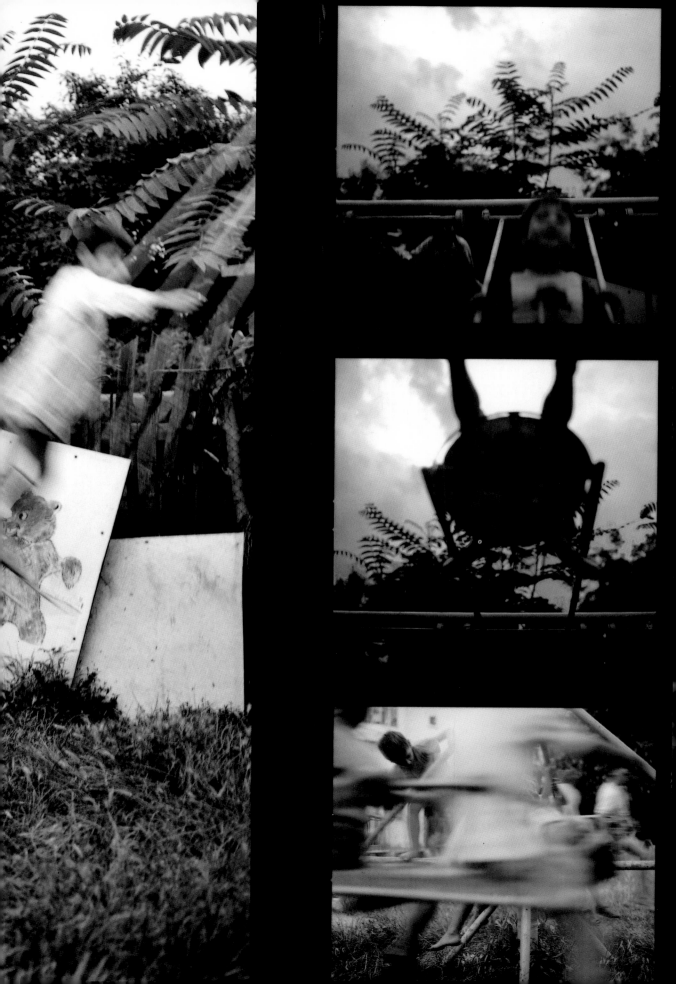

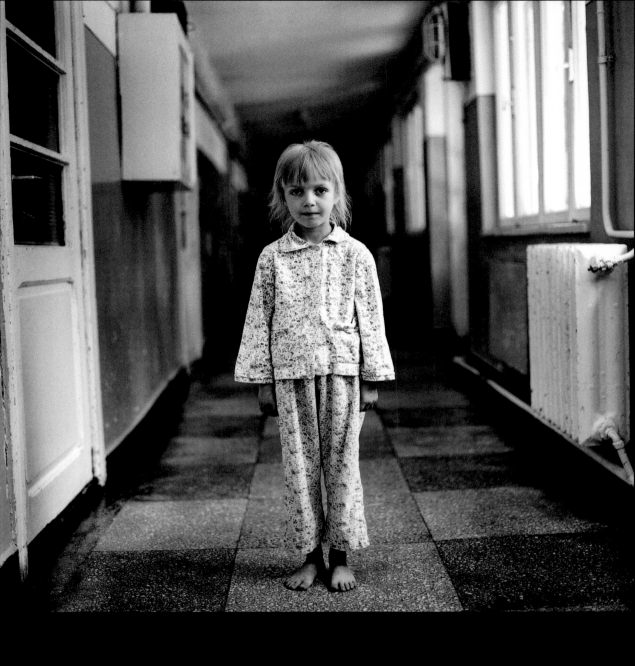

62,63. Focsani 64. Ana-Maria

Stories from
St. Laurence Children's Hospice
and the Orphanage
in Cernavoda

*These stories have been taken from
the notes of the caseworkers at the above institutions.
Some of the names have been changed
to protect the children.*

NAME: TURKIAN

DATE OF BIRTH: May 19, 1988
SEX: FEMALE
HIV STATUS: POSITIVE
WEIGHT: 20 kg (44 pounds)
HEIGHT: 119 cm (3 feet, 11 inches)
EYES: BROWN
SKIN: DARK
HAIR: BLACK

Family Life:

Turkian was born on May 19, 1988 in Medgidia Hospital in Constanta, southeastern Romania. Her mother was just sixteen when she gave birth. She was deaf and dumb and her left arm was disabled. The father is not named on the birth certificate. The mother lived in a two-bedroom apartment with fourteen other people, none of whom had jobs. For all these reasons Turkian was given up at birth.

Orphanage Life:

On October 16, 1989, Turkian was moved from the hospital to the Cernavoda Orphanage where she spent her childhood years. She has never been visited by any family member.

On January 26, 1990, Turkian first tested HIV Positive, although she was uninfected at birth. However, all young children considered unhealthy in the orphanage had been given blood transfusions. The blood was never screened and needles never sterilized. As a result, infection was rife. Turkian now also suffers from TB. In February 1998 she had to go into the AIDS hospital in Constanta, where she stayed for four months and recovered. Turkian was not well enough to return to the orphanage, so another charity in Cernavoda that runs a hospice agreed to care for her.

New Beginnings:

On October 13, 1998, Turkian moved into Nightingales Home and School, also called Casa Fericirii or "Home of Happiness." This complex was built specifically for Turkian and her friends from Cernavoda Orphanage, who are all HIV Positive. Turkian is a lovely little girl. She says the best thing about her new home is that she can let her hair grow for the first time. She can't wait until it is long enough to put up in pigtails.

NAME: ALEXANDRU

DATE OF BIRTH: April 9, 1987
SEX: MALE
HIV STATUS: POSITIVE
WEIGHT: 34 kg (74.8 pounds)
HEIGHT: 135 cm (4 feet, 5 inches)
EYES: BLUE
SKIN: FAIR
HAIR: LIGHT BROWN

Family History:
Alexandru was born on April 9, 1987 in the Constanta Hospital. Alexandru's mother lived with her elderly grandmother who was very frail and ill. They lived in very poor conditions which were inadequate to raise a child. The mother was not married when she became pregnant. As a result, Alexandru was abandoned shortly after birth.

Orphanage Life:
On March 28, 1989, Alexandru was moved from the Constanta Hospital to the Cernavoda Orphanage, where he spent his childhood. While in the orphanage he was visited once a year by his new stepfather, who brought him sweets and biscuits.

On January 26, 1990, Alexandru first tested HIV Positive, though he was without infection at birth. Despite his HIV status, Alexandru has few health problems. He does have a severe hernia on his right testicle, which, although treatable, no doctor in Romania will operate on because the boy is HIV Positive. Alexandru says it does not hurt him, but he does find it embarrassing at times.

New Beginnings:
On September 17, 1998 Alexandru moved into the Nightingales Home and School. Alexandru is one of the most mature children in the group, although he is still immature for his age. He has really benefited from leaving the orphanage, where his relative maturity was not acknowledged. This used to frustrate Alexandru into fits of violent rage. He would smash windows and end up hurting himself. In his new home he has much more freedom. The caretaker, Sandu, who works and lives at the school, has taken a shine to Alexandru, which is lovely for Alexandru as he has had very little male company during his life. Sandu has a boy of the same age, called Alex. The children play nicely together and are given many small jobs by Sandu which keeps them both busy and out of trouble. We are all very proud of Alexandru, who is slowly changing into a very helpful, polite, and loving young boy.

NAME: ELENA

DATE OF BIRTH: September 28, 1987
SEX: FEMALE
HIV STATUS: POSITIVE
WEIGHT: 17 kg (37.4 pounds)
HEIGHT: 107 cm (3 feet, 5 inches)
EYES: BROWN
SKIN: FAIR
HAIR: LIGHT BROWN

Family History:
Elena and her twin Constantin were born on September 28, 1987 in Medgidia Hospital in Constanta. Their mother was ill, an alcoholic, and did not live in conditions adequate to care for two babies. Their father died on February 3, 1988 and their mother gave the children up soon after.

Orphanage Life:
On December 27, 1988, Elena was moved from the hospital to the Cernavoda Orphanage. Unfortunately, we have no record of which orphanage her twin Constantin was moved to, or where he is now. Elena, always an introverted child, did not have a very happy childhood. She was considered a special needs child by orphanage staff, when in fact she was just severely underdeveloped as a result of institutionali- sation. Elena is actually very intelligent and inquisitive.

Two years after coming to the orphanage, on February 28, 1990, Elena first tested HIV Positive.

New Beginnings:
On September 17, 1998, Elena moved into Nightingales. Since moving into a more caring and secure family environment, Elena has really come out of her shell. She is now visibly happier and her speech has started to improve. Elena used to say only a few words, very quietly: *Da* for yes, and *PaPa* for bye- bye. She will now copy words that are said to her and can sometimes be heard laughing or screaming in delight. Elena is in school at a very basic kindergarten level. She is beginning to enjoy classes and we are looking forward to seeing more progress in Elena in the near future.

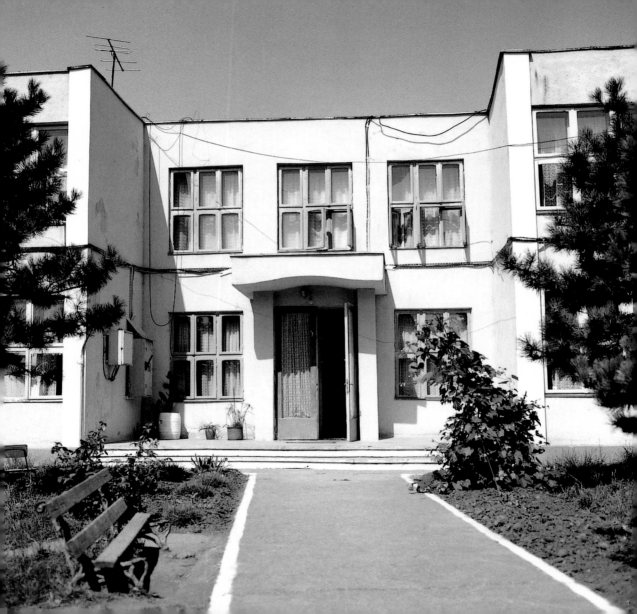

NAME: VASILE

DATE OF BIRTH: June 6, 1988
SEX: MALE
HIV STATUS: POSITIVE
WEIGHT: 20 kg (44 pounds)
HEIGHT: 113 cm (3 feet, 4 inches)
EYES: BROWN
SKIN: DARK
HAIR: DARK BROWN

Family History:

Vasile was born on July 6, 1988 in Constanta Hospital. Vasile's mother abandoned him at the hospital immediately after giving birth. When the police went to find her, the address she had given the hospital no longer existed; she had disappeared. No father was named on the birth certificate.

Orphanage Life:

On December 27, 1989, Vasile was moved from Constanta Hospital to the orphanage in Cernavoda. Vasile was always desperate to please the nurses in the orphanage by being well behaved as well as quick-witted and funny.

On January 26, 1990, Vasile first tested HIV Positive. How he became infected is unknown, though blood transfusions are suspected. In Vasile's last year at the orphanage he refused to eat and had constant diarrhea, which meant he lost a lot of weight. At around the same time he caught TB and became very sick. Vasile has spent long periods in the hospital but does not get upset as he is very popular and knows the nurses well.

New Beginnings:

On September 17, 1998, Vasile moved into Nightingales Home and School. Vasile is very happy in his new home and is definitely benefiting from living in a family environment. Vasile loves dogs and has even invented his own doggy language; he clenches his fists to make paws and makes funny canine noises. Vasile is a wonderful little boy who is full of fun and laughter.

NAME: ADRIANA

DATE OF BIRTH: March 1, 1987
SEX: FEMALE
HIV STATUS: NEGATIVE
WEIGHT: 30 kg (66 pounds)
HEIGHT: 131 cm (4 feet, 3.5 inches)
EYES: BROWN
SKIN: FAIR
HAIR: DARK BROWN

Family History:

Adriana was born on March 1, 1987 in the Constanta hospital, southeast Romania. Her mother had mental health problems and did not live in conditions adequate to care for Adriana. Her father died on November 30, 1986. Adriana was abandoned shortly after birth.

Orphanage Life:

Soon after birth, Adriana was transferred from the Constanta Hospital to the orphanage in Cernavoda, where she spent her first three years. According to her records, she first tested HIV Positive on January 26, 1990 and was retested on April 11, 1994. On the latter certificate there is a handwritten note from Adriana's doctor stating that she was found to be HIV Negative. Even though we now know Adriana is HIV Negative (and our institution only houses HIV Positive children), we feel she would not benefit from moving to another institution. This is now her home and the children from the orphanage that she has grown up with are her family.

New Beginnings:

On September 17, 1998, Adriana moved into Nightingales Home and School. This complex was built specifically for Adriana and her twenty friends from Cernavoda Orphanage, who, apart from Adriana, are all HIV Positive. Adriana is a very intelligent child who is doing very well at school. She is always well behaved and concentrates hard on her work. She has a wide vocabulary and comprehends everything, though she has a severe speech impediment and is consequently very hard to understand. When you get to know Adriana you can work out what she is saying by the change in her rhythm and tone. Adriana is generally quiet and sometimes shy; she loves attention but never demands it. Adriana is a wonderful little girl and a pleasure to care for.

NAME: RAMONA

DATE OF BIRTH: July 19, 1988
SEX: FEMALE
HIV STATUS: POSITIVE
WEIGHT: 24 kg (52.8 pounds)
HEIGHT: 127 cm (4 feet, 2 inches)
EYES: BROWN
SKIN: OLIVE
HAIR: DARK BROWN

Family History:
Ramona was born on July 19, 1988 in Constanta Hospital. Her mother was an unemployed alcoholic; Ramona's father was unknown. Ramona's mother initially took her home, but after leaving the baby for long periods, it became apparent that she couldn't cope, and so Ramona was taken back to Constanta hospital and abandoned.

Orphanage Life:
On October 16, 1989, Ramona was moved from the hospital to the Cernavoda orphanage. While there, Ramona was never visited by any family member.

On January 26, 1990, Ramona first tested HIV Positive. She did not have HIV at birth and how she became infected is unknown. Blood transfusions, where the blood used was not screened and needles were never sterilized, are suspected.

New Beginnings:
On September 17, 1998, Ramona moved into the "Home of Happiness". Ramona is much happier and more confident since she has moved into her new home. Here she knows that she receives more love and individual attention than she did in the orphanage. Ramona is a beautiful little girl and loves anything girly! She loves to dress up, paint her nails and keeps begging us to pierce her ears. She is also very pleased that she can now grow her hair long, which was never possible in the orphanage

NAME: FLORIN

DATE OF BIRTH: April 21, 1989
SEX: MALE
DATE OF DEATH: September 10, 1997

Florin was admitted to the hospice on July 28, 1997 from Constanta Hospital. He was very ill when he arrived and his little body was covered in sores and fungal infections. At first he was terrified of taking a bath but was gradually coaxed in with lots of hot water and bubbles. He began to enjoy having baths, and it really seemed to ease and comfort his pain. He gradually started requesting baths more and more often, until he was finally spending more time in the bath than not. He would put a pillow in the bath and just lie there for hours, with a beautiful smile on his face, letting the hot water slowly soothe his sores. Florin died around the time that Princess Diana died. There was so much fuss and commotion going on about her death and it seemed like the whole world was mourning for her. Meanwhile, in a hospice in a small town in Romania, a small group of ten or so people gathered to mourn the life of an eight-year-old boy.

NAME: CARMEN

DATE OF BIRTH: October 2, 1988
SEX: FEMALE
DATE OF DEATH: May 17, 1998

Carmen was abandoned at an orphanage in Botosani in March 1996. There were eight other children in the family and they were very poor, living in a two-bedroom apartment with an alcoholic father. When Carmen first came to us on May 30, 1996, she was self-abusive and unable to walk, talk, or feed herself. With lots of patience, attention, and care, she gradually came out of herself and began to walk and feed herself and communicate with her caregivers. She died in 1998 and her parents, on receiving a telegram about her death, made the long journey across Romania to attend her funeral, although they had had no contact with her during the two years she was in the hospice, and possibly did not know of her whereabouts.

NAME: CLAUDIA

DATE OF BIRTH: March 30, 1990
SEX: FEMALE
DATE OF DEATH: October 13, 1998

Claudia was a beautiful little girl and a real character. She was abandoned in a rubbish bin and as a result of this, some of her toes and fingers were missing from rats having chewed them. She was admitted to Pucisoasa Orphanage and then transferred to the hospice on January 13, 1994. When she arrived she was a shy and terrified little thing, but with lots of patience and one-on-one attention, she gradually came out of her shell and learned to respond to people and to communicate, to love and be loved. She started walking and talking and soon developed an affinity for make up and having her hair done. She was very particular about which clothes she wanted to wear each day and had a real sense of humor and a beautiful smile.

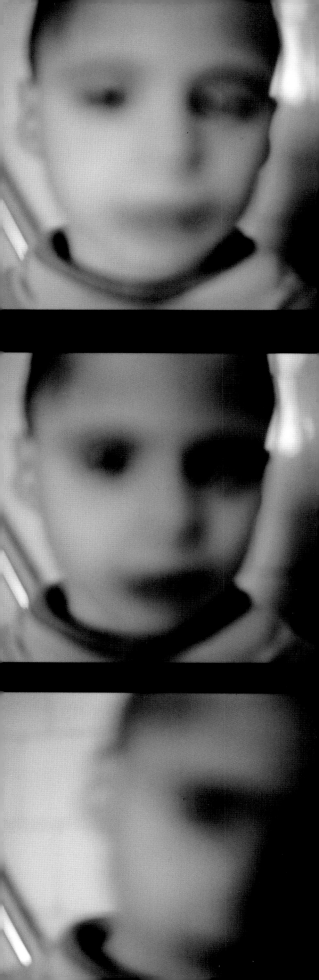

NAME: MARIAN

DATE OF BIRTH: September 28, 1988
SEX: MALE
HIV STATUS: POSITIVE
WEIGHT: 20 kg (44 pounds)
HEIGHT: 121 cm (4 feet)
EYES: BROWN
SKIN: FAIR
HAIR: LIGHT BROWN

Family History:
Marian was born on September 28, 1988 in Constanta Hospital. Marian's family was very poor. His mother had a disability and at the time she became pregnant, her husband had just been given a two-year prison sentence. She already had two young children and could not care for another baby, so Marian was given up at birth.

Orphanage Life:
On October 27, 1989, Marian was moved from the hospital to the orphanage in Cernavoda. Marian's father came to visit him and brought him treats, but only once a year, so Marian was a little shy around him. After his father had left, Marian would get very excited about the visit and the presents.

On January 26, 1990, Marian first tested HIV Positive; how he became infected is not known, but blood transfusions are likely.

New Beginnings:
On September 17, 1998, Marian moved into Casa Fericirii. Marian has very good manners and is always very polite when speaking to adults. He is also very popular and exceptionally well behaved in class. His favorite subject is mathematics and when he grows up he wants to teach mathematics at Cernavoda College. Since staying in our care Marian has had a letter from his mother. She wrote to ask if he was well and happy and said she was sorry for not visiting as she had been sick herself and short of money. Marian was thrilled with his letter and wrote back with the help of his teacher, enclosing a photograph of himself (since his mother has not seen him since birth). Marian is still awaiting a reply.

NAME: MARIANA

DATE OF BIRTH: February 21, 1989
SEX: FEMALE
HIV STATUS: POSITIVE

Family History:
Mariana was abandoned by her mother on the streets of Constanta and was found and taken into a hospital there.

Hospice Life
After spending a short time in Constanta Hospital, she arrived at the hospice in January 16, 1995.
On coming to Cernavoda, she had a few small sores on her face, like small warts but unrelated to the AIDS virus, and called *molluscum contagius*. They gradually spread and grew larger, mostly on her face but on other parts of her body too, her arms and legs. Finally they got so bad that her face was completely covered and you could hardly even see her eyes. By the summer the sores became infected and flies began laying eggs in them. We used to have to pull live maggots out of her face while she lay there patiently. The smell used to be so bad that the other children wouldn't play with Mariana. She used to be so withdrawn and sit on her bed on her own, rocking back and forth to comfort herself. I think she is one of the bravest children I have ever met: a fighter, with so much courage.

In March 1997, she was taken by an Italian charity to Rome for a series of operations. She spent six months in Italy undergoing treatment. When she came back she was like a different child. Her face was completely clear expect for the scarring, and she was lively and happy. Since then she has grown even stronger. She is now a young lady with beautiful long brown hair, who loves wearing make up and takes such pride in her appearance, dressing in all the latest fashions. She is a real mother to the younger children. There is one young boy, in her house who she takes complete care of – changing him, dressing him, feeding him, and dropping him off at school every day. She is popular and affectionate, with a real lively sense of humor. She is unrecognizable from the sad, withdrawn little girl she was four years ago.

MORE THAN A DECADE after the fall of the Iron Curtain and the overthrow and execution of brutal Romanian dictator Nicholae Ceausescu, the worst AIDS epidemic among children in the world bears out its infamous legacy in Romania, still one of the poorest and most fractured societies in Eastern Europe. In the late 1980s and early 1990s, tens of thousands of children in government hospitals and orphanages were systematically infected by unsterilized needles and HIV-tainted blood transfusions given to them instead of food. Over this last decade, thousands have died, but almost 10,000 children with AIDS remain. The tragedy continues.

While in power, Ceausescu dismissed AIDS as a disease restricted to capitalist countries, and diverted funds from health care and other social programs in order to repay the foreign debt. In the months after Ceausescu's death, the full import of the dictator's social policies began to reveal itself in full horror. His attempts to boost the workforce by fining infertility and banning birth control and abortion were exacerbated by his encouragement to parents to surrender their children to the state if they could not care for them during times of personal crisis (partly because of the Communist belief that the state was more competent than the individual and in part because hospital budgets increased as the caseloads grew).

DURING CEAUSESCU'S reign, birthrates outpaced impoverished families' ability to care for their own children, and unwanted and abandoned children swelled orphanage populations to bursting. Fresh milk, vitamins, and food were scarce, so institutions were told to treat the malnourished and anemic children with a fast-fix "pick-me-up" consisting of transfusions of unscreened plasma. Compounding the issue, caseworkers often re-used vaccination needles on children, frequently using one needle on as many as ten children. The result: widespread AIDS throughout the child population. The health authorities knew about the situation, as well as the harrowing conditions within orphanages, where children lay screaming, unwashed, filthy, packed into death wards, but were too frightened to speak out.

When the scandal broke, help poured in from all over the world. Blood testing improved; hospitals got disposable syringes; nurses were retrained. But the damage to the children was irreversible, and many began to die.

Beginning in 1994 and for the next five years, Magnum photographer Kent Klich traveled to Romania to document the appalling aftermath of Ceausescu's horror. Klich, who began his career as a psychologist working with adolescents with a history of social problems, traveled throughout Romania to visit the orphanages and hospitals struggling with the burden of this legacy. In *Children of Ceausescu,* Klich gives us visceral images and brief life stories of the boys and girls who suffer still from the state's mass experiment. Compassionate yet unflinching, these photographs give us a glimpse of the daily lives of these children, both terrible and mundane. They run and jump in puddles, they laugh out loud and draw pictures of flowers and birds, but they also know disease and death intimately, and the realities of their infection are overpowering.

It has been over a decade since full disclosure of the facts of this situation has been brought to the world's attention. Conditions have improved, thanks to the intervention of foreign non-governmental organizations and the willingness of Romanian government and medical personnel to finally confront the issue. Even so, the situation is one of sustained crisis without foreseeable end. AIDS in Romania is overwhelmingly among children and within that subset, among orphaned children with no political clout; the Romanian government has failed through corruption and bureaucracy, to offer hope. There is not enough money for the high-priced, triple-therapy anti-retroviral drugs for all young patients, forcing the caretakers to choose who receives medication and who must suffer without. Many of the multinational drug companies have stood firm in greed and defense of patents and refused to offer discounts. Ignorance of the situation is now no excuse. These are deaths that are preventable. And there is so much to be done for these innocents – still.

The Editors

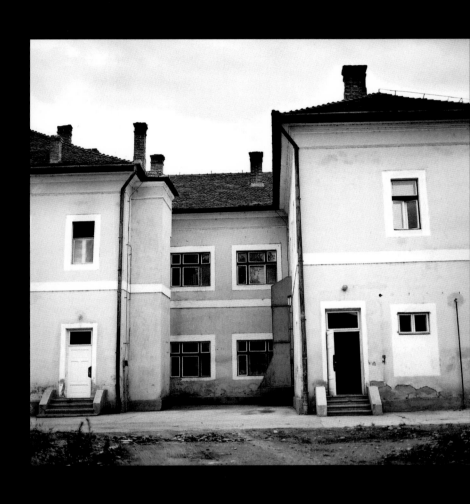

66. Tita 67. Targu Mures

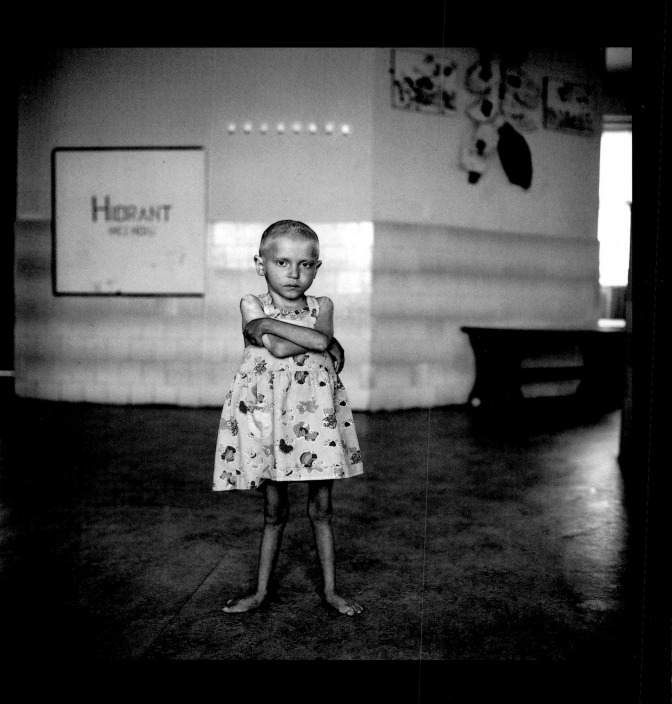

68. Claudia 69. Iliaz

Statement

by Kent Klich

I WAS AFRAID OF MEETING DEATH, but the children were so full of life that I forgot that they were going to die.

Every garment was marked with a number. None of the children had clothes of their own. Their meals of soup, porridge, and bread were served at tremendous speed and eaten in the same way. Children who ate slowly were made to hurry up. There were no medicines, no gloves, no disposible syringes.

When I first went to Romania in 1994, HIV-positive children, whose life expectancy was assumed to be no more than two or three years, were at the bottom of the heap when it came to care.

The state orphanage in Cernavoda sits in the hills overlooking the entrance to the Danube-Black Sea Canal. Of the 200 children living there in 1994, around 30 in ward eighteen were HIV Positive. The local staff were supplemented by volunters from Nightingales, a British charity which began working in Cernavoda in 1993. Their rooms were bare, the metal beds stood in rows, there were no signs of toys and pictures. Although the children were allowed to play outside, I often found them sitting quietly in their dormitories, doing nothing.

Tita was a little girl of six years old when I met her the first time. She looked up at me fearfully while gulping water from a big cup. I could only see one eye. Did she think that I would steal her drink? When I photographed her she very seldom looked at me, her eyes glanced over at me and away. In many of the children I met during my travels through Romania I sensed the recalled fear of harsh treatments. How could it have happened that in 1989, 100,000 undernourished children were kept in institutions reminiscent of Nazi concentration camps? They were left lying in their own feces, bound hand and foot, maltreated by their "guards." No one touched them gently.

How could caretakers in hospitals and orphanages with good intentions stand by as their fellow workers mistreated the children? How was it possible that doctors and nurses, normally looked upon as saviours, could be executioners as well, infecting many children with the HIV virus?

A doctor at a hospital for HIV-positive children in southern Romania admits that she knew and many of her colleages knew that AIDS did exist in Romania during Ceausescu. She felt they were not able to protect the children out of fear: fear of disappearance, of being jailed — fear that something bad would happen to them and their families. When the doctor was young she had accused her parents of not doing anything to change the Communist system. Now, she says, her son is accusing her of having watched the children become infected with HIV without having done anything.

At the Colentina Hospital in Bucharest, at least there were playrooms and staff to play with the children. Health Aid, a British organization which has worked with HIV-positive children in Romania since 1990, brought in medical supplies and were helping to train Romanian caregivers to work in the three small homes they had established for HIV-positive children. In one of them, in Snagoff, a village near Bucharest, eight children live as a family with people who love them.

In Snagoff, the children have a history. Each child has his or her own photo album in which they make a record of the events in their lives. When one of the children dies — as, inevitably, some do — their memory is kept alive by photographs. While I was there I noticed a picture of a boy who had died a couple of months earlier hanging on the livingroom wall. His memory lived on within the family.

In 1998, twenty children from the orphanage in Cernavoda moved into a new building run by Nightingales, where they live and go to school. Health Aid now has six homes instead of three. David Savage at Nightingales tells me that out of the thirty children who were HIV Positive in 1994, ten have died. Only two of the twenty children living with them are on retroviral treatment. He thinks that fifteen should have it. They can't get the medicine. In the meantime — against hope — they prepare them for a life outside.

I would like to thank Fred Ritchin, Carole Naggar, and Tina Enghoff for their support during this project. Thanks to Herta Müller for writing the text that only she could.

I am also grateful to Nan Richardson, Lesley A. Martin, Gösta Flemming and Göran Widerberg. Per-Erik Åström from Swedish Save the Children, who put me in contact with Anne McNicholas and Tina Petrescu from Health Aid, as well as all their staff; Dr Matusa with her staff at the Municipal Hospital in Constanta; David Savage and Lisa Gavrila, and all their staff at Nightingales; Katherine Bainbridge and all the staff at St. Laurence Hospice in Cernavoda; as well as all staff who let me in at hospitals and children's home to continously report of the situation for the HIV-positive children in Romania; The Colentina Hospital and the Victor Babes Hospital, Bucharest; Placement Center No. 7, Vidra; the Childrens Home in Giurgiu; The Infectious Diseases Clinic No. 1, Targu Mures; The Childrens Home No. 2 in Focsani; Casa Speranta in Constanta; Romanian Angel Appeal, Hospital No. 3 in Galati; County Hospital in Bacau; The Municipal Hospital in Piatra Neamt; Casa Gulliver in Iasi; and Childrens Home No. 2 in Botosani.

Notes on the Plates

Plate 1. Valerica, Cernavoda Orphanage, 1995.

Plate 2. Florin, St. Laurence Children's Hospice, Cernavoda, 1997.

Plate 3. Irina, Children's Home No. 2, Focsani, 1997.

Plate 4. Sebastian, St. Laurence Children's Hospice, Cernavoda, 1997.

Plate 5. Valerica, Cernavoda Orphanage, 1995.

Plate 6,7. Claudia, St. Laurence Children's Hospice,Cernavoda,1997.

Plate 8,9. Cornelia, St. Laurence Children's Hospice,Cernavoda,1997.

Plate 10. Mirabela, Colentina Hospital, Bucharest, 1995.

Plate 11. Ileana, Children's Home for HIV-positive children, Giurgiu, 1997.

Plate 12. Mariana, St. Laurence Children's Hospice, Cernavoda, 1996.

Plate 13. Mariana, St. Laurence Children's Hospice, Cernavoda, 1998

Plate 14. Cornelia, St. Laurence Children's Hospice, Cernavoda, 1997.

Plate 15. Vervel,Victor Babes Hospital, Bucharest, 1996.

Plate 16. Stefan, Hospital No. 3, Galati, 1997.

Plate 17. Claudia, St. Laurence Children's Hospice, Cernavoda, 1997.

Plate 18. Carmen, St. Laurence Children's Hospice, Cernavoda, 1997.

Plate 19. Iounut, St. Laurence Children's Hospice, Cernavoda, 1997.

Plate 20. Claudiu, Gulliver House, Iasi, 1996.

Plate 21. Laura, Cernavoda Orphanage, 1996.

Plate 22. Oana, St. Laurence Children's Hospice, Cernavoda, 1997.

Plate 23. Ana-Maria, Hospital No. 3, Galati, 1996.

Plate 24. Florin, St. Laurence Children's Hospice, Cernavoda, 1997.

Plate 25. Cornelia, St. Laurence Children's Hospice, Cernavoda, 1996.

Plate 26. Mehai, Municipal Hospital, Constanta, 1997.

Plate 27. Valerica, Cernavoda Orphanage, 1996.

Plate 28. Sebastian, St. Laurence Children's Hospice, Cernavoda, 1997.

Plate 29. St. Laurence Children's Hospice, Cernavoda, 1997.

Plate 30. Municipal Hospital, Constanta, 1995.

Plate 31. Tita, Cernavoda Orphanage, 1995.

Plate 32. Cernavoda Orphanage, 1995.

Plate 33. Adriana, Cernavoda Orphanage, 1995.

Plate 34. Placement Center No. 7, Vidra, 1996.

Plate 35. Georgiana,Victor Babes Hospital, Bucharest, 1996.

Plate 36. Carmen, St. Laurence Children's Hospice, Cernavoda, 1997.

Plate 37,38. Carmen, St. Laurence Children's Hospice, Cernavoda, 1997.

Plate 39. Sofia, St. Laurence Children's Hospice, Cernavoda, 1996.

Plate 40,41. Hospital No. 3, Galati, 1996.

Plate 42. Nicu, St. Laurence Children's Hospice, Cernavoda, 1999.

Plate 43. Simona, Childrens Home No. 2, Botosani, 1996.

Plate 44. Tita, Cernavoda Orphanage, 1995.

Plate 45. Nina, Cernavoda Orphanage, 1995.

Plate 46. Elena, Cernavoda Orphanage, 1995.

Plate 47. Placement Center No. 7,Vidra, 1996.

Plate 48. Sevastita, Cernavoda Orphanage,1995.

Plate 49. Laura, Cernavoda Orphanage, 1996.

Plate 50. Niculeta, Municipal Hospital,Constanta 1997.

Plate 51. Florin, St. Laurence Children's Hospice, Cernavoda, 1997.

Plate 52. Tita, Cernavoda Orphanage, 1996.

Plate 53. Infectious Diseases Clinic No. 1,Targu Mures, 1997.

Plate 54. Vervel,Victor Babes Hospital, Bucharest, 1996.

Plate 55. Daniel, St. Laurence Children's Hospice, Cernavoda, 1996.

Plate 56. Laura and Lisa, Cernavoda Orphanage, 1996.

Plate 57. Claudia, St. Laurence Children's Hospice, Cernavoda, 1997.

Plate 58. Iliaz, Cernavoda Orphanage, 1997.

Plate 59. Laura, Cernavoda Orphanage, 1996.

Plate 60,61. Cornelia, St. Laurence Children's Hospice, Cernavoda, 1996.

Plate 62,63. Children's Home No. 2, Focsani, 1997.

Plate 64. Ana-Maria, Hospital No. 3, Galati, 1997.

Plate 65. Children's Home for HIV-positive children, Giurgiu, 1997.

Plate 66. Tita, Cernavoda Orphanage, 1995.

Plate 67. Infectious Diseases Clinic No. 1,Targu Mures, 1997.

Plate 68. Claudia, St. Laurence Children's Hospice, Cernavoda, 1997.

Plate 69. Iliaz, Cernavoda Orphanage, 1997.

Cover. Claudia St. Laurence Children's Hospice, Cernavoda, 1997.

Backcover. Tita, Cernavoda Orphanage, 1997.

As a courtesy, some of the names have been changed.

KENT KLICH was born in Sweden in 1952. He studied psychology at the University of Gothenburg. After earning his degree he worked with adolescents with a history of social problems. In 1983 he met Beth R. a drug addict and a prostitute, together they made *The Book of Beth* (Aperture, 1989), documenting her life and including case records from her childhood.

Klich's work in the 1990s in Mexico City with street children was recently published by Journal and Syracuse University Press, with a text by Elena Poniatowska, as *El Nino: Children of the Streets, Mexico City*. He joined Magnum in 1998 and his work has been the subject of numerous exhibitions in Europe and elsewhere, including the Rencontres de Perpignan, France 1999.

HERTA MÜLLER was born in Romania in 1953. After refusing to co-operate with Ceausescu's Securitate, she lost her job as a teacher and suffered repeated threats before she was able to emigrate in 1987. She is the author of *Traveling on One Leg* (Northwestern University Press, 1998) and *The Land of Green Plums* (Henry Holt & Company, Inc., 1996), among other titles. In addition to the Dublin IMPAC Literary Award she has received many prizes for her work including Germany`s most prestigious literary award, The Kleist Prize. Herta Müller now lives in Berlin.

Children of Ceausescu copyright © 2001 Umbrage Editions
Photographs copyright © 2001 Kent Klich/Magnum
Essay copyright © 2001 Herta Müller

European English-language edition: copyright © 2001 Journal
Swedish edition: copyright © 2001 Journal

First Edition

English language HC ISBN 1-884167-10-1
European English language HC ISBN 91-974182-1-8
Swedish language HC ISBN 91-974182-2-6

Published by:
Umbrage Editions, Inc.
515 Canal Street
New York, New York 10013

Publisher: Nan Richardson
Managing Editor: Lesley A. Martin
Assistant Editor/Exhibitions Coordinator: Sara Goldsmith
Editorial Assistants: Megan Thomas, Holly Popowski
Copy Editor: Sara Cameron

Design and Layout by Tina Enghoff and Fred Ritchin
Photographs printed by Lars Trädgårdh

This book is simultaneously published in Europe by:
Journal
info@journal-media.se
Editor: Gösta Flemming

Printed in Italy by Mondadori, Verona

Children of Ceausescu was made possible in part by funding from the Arts Grants Committee and Erna & Victor Hasselblad Foundation, Sweden.

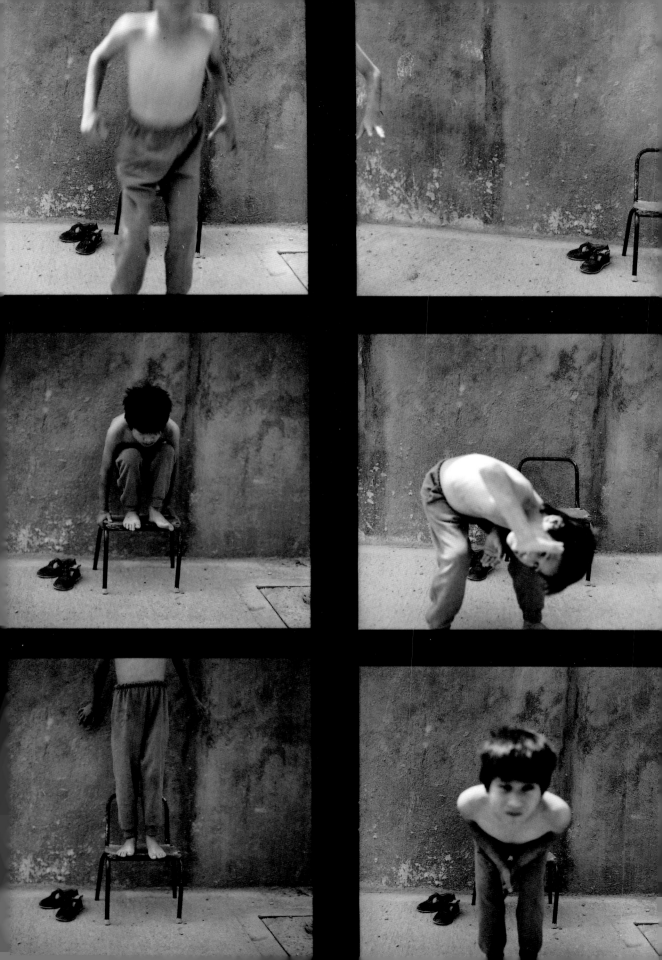